the KODAK Workshop Series

Lenses for 35mm Photography

the **KODAK Workshop Series**

Lenses for 35mm Photography

Written by Artur Landt

the KODAK Workshop Series

Helping to expand your understanding of photography

Lenses for 35mm Photography

Written by Artur Landt

Edited by Steve Pollock

Creative photography by Artur Landt

Product photos and illustrations provided by their respective manufacturers

Product names cited in this publication are registered trademarks of their respective manufacturers.

Publication KW-18

Cat. No. E144 1757

Library of Congress Catalog Card Number 95-73080

ISBN 0-87985-765-X

Printed in Germany by Kösel GmbH, Kempten

The information in this book is based on thorough research, yet not every detail could be verified. Information, data, and procedures are therefore correct to the author and publisher's knowledge; all other liability is expressly disclaimed. This book was neither initiated nor sponsored by any lens manufacturing company, and the author did not receive and/or follow any instructions or demands from any manufacturer concerning the manuscript.

LICENSED PRODUCT

KODAK Books are published under license from Eastman Kodak Company by
Silver Pixel Press®
21 Jet View Drive
Rochester, NY 14624 USA
Fax: (716) 328-5078

Contents

Preface

If it is impossible for the photographer to step back and encompass the entire scene in the photograph, a wide-angle lens can be used. If the photographer is unable to get close enough to a subject, a telephoto lens can solve the problem. So far so good. However, photographers selecting lenses to cover situations similar to these are not making the most of their lenses. Optimally, lenses are chosen to record the subject as it should appear in the final picture, relative to the photographer's own position.

Practical photography demands the use of various focal length lenses according to the composition required. As a result, interchangeable lenses not only expand a camera's range of possibilities, but also enable a photographer to record the exact view of the subject required. This book was compiled for anyone who wishes to make maximum use of the wide variety of lenses available.

Lenses for 35mm Photography is clearly arranged for and related to everyday use. The book covers the basic theoretical, technical, and practical information vital for taking high-quality photographs with cameras using interchangeable lenses from 13mm to 1200mm.

Fixed focal length and zoom lenses are covered as are manual and autofocus lenses. Special lenses, such as perspective-control, fisheye, macro, mirror, and apochromatic lenses, are also discussed.

All aspects of interchangeable lenses are discussed in depth with photographs to illustrate the topics covered. A typical use for each focal length lens is suggested across a wide range of subjects.

Also, the book covers exactly how to handle lenses professionally with respect to focusing, image control, reproduction ratio, and optimum aperture. For example, the effects of focal length on the photograph and why perspective is

not determined solely by the lens are explained. In addition, the correct use of lens accessories, such as filters, close-up attachments, various lens shades, teleconverters, bellows units, and extension tubes, are described.

Due to the complexity of the subject and the restriction of the book's length, priorities had to be set. Therefore less-essential items like lens offerings and specification charts from manufacturers have been omitted—they would have become obsolete after a short while anyway. The camera companies' prevailing policy seems to be to introduce new lens models and discontinue existing ones at an ever-increasing rate. Photographers who are interested in a particular lens or lens system should check with the manufacturer.

The Author:
Dr. Artur Landt, born in 1958, is the editor in charge of the column "Test und Technik" in the German photo magazine Color Foto. *As an author of special-interest books and a freelance photographer, he is well acquainted with the theoretical and practical aspects of photography.*

Lens Basics

In order to get the most from your lenses, it helps to know how they work. Basic knowledge of lens principles and construction is particularly handy when reading the technical data for a special lens you are investigating. Such information is not a prerequisite for the use of interchangeable lenses, only an aid to selecting the right lens for the desired effect. Due to limited space and the complex nature of lens design, only the highlights can be touched on here.

Lens Construction

In the early days of telescope development, the term "lens" referred to the part of an optical system facing the subject. Today, a lens is any image-forming optical system.

In photography, the purpose of the lens is to form an image of an object at the focal plane (i.e. on the film). A photographic lens can consist of a single element, or more commonly of several elements arranged separately and/or cemented together to form "groups." A concave mirror can also serve as a lens.

In principle every lens, regardless of the number of elements, works like a single convex element, similar to a magnifying glass. In order to create an image of an object, a lens depends on light being reflected from the object. Every one of the tiny points constituting a subject's surface reflects light toward the lens. To help illustrate what happens next, imagine that all the light entering the lens is reduced to a single ray, whose path can be followed to the film plane. In optical terms, this light ray's only significant dimension is its length. We can safely ignore all theoretical questions of its width, height, or diameter.

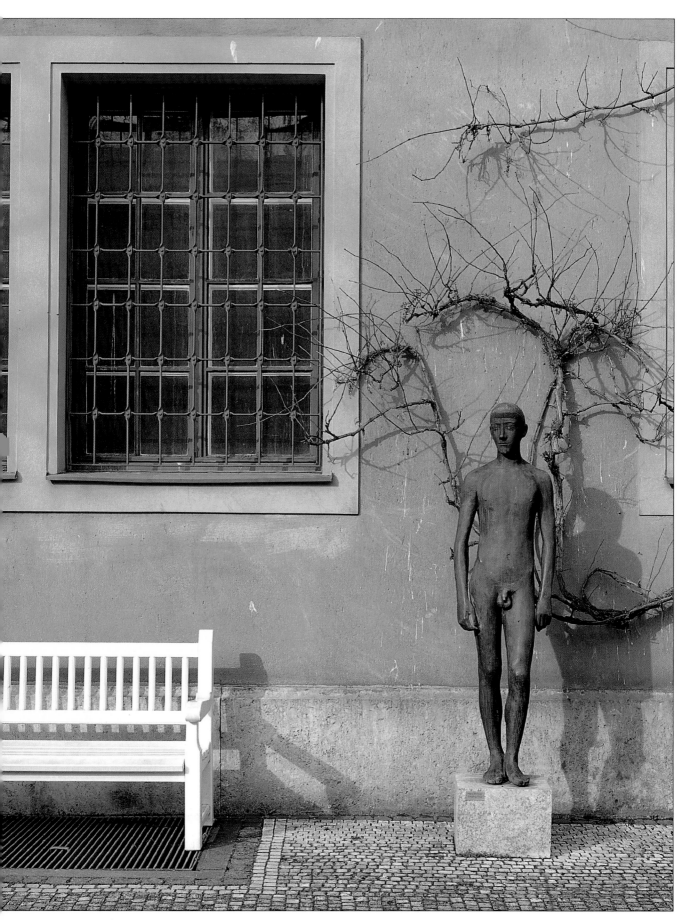

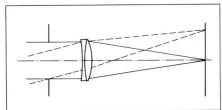

A meniscal lens is a simple, single-element lens with two identically curved surfaces. By varying the thickness, curvature, and refractive index of the glass, as well as the element's position in relation to the diaphragm, aberrations could be controlled to some extent.

This achromatic optical design is called the French landscape lens. While used for the very first photographic experiments by Niépce, Daguerre, and Talbot, it is still found in some telephoto and close-up lenses of today. Its biconvex and biconcave elements made of two different types of glass correct somewhat for two of the primary colors.

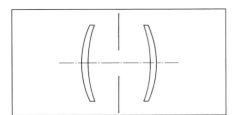

The "Periskop" lens was developed in 1865 by placing two single elements symmetrically on either side of the diaphragm. This arrangement of elements displays low distortion, coma, astigmatism, and curvature of field, but spherical and chromatic aberrations remained uncorrected.

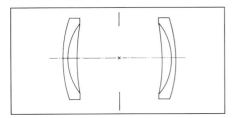

In 1867 the aplanatic lens was developed featuring two groups of cemented achromatic elements arranged symmetrically opposite the diaphragm.

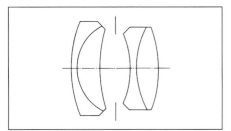

The Zeiss Protar lens developed in 1890 has a speed of f/7.5 and shows little astigmatism or spherical aberration. It consists of four elements that are arranged into two groups.

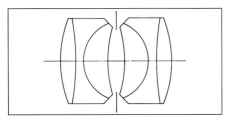

The Dagor, developed in 1892, is a typical example of a double anastigmat constructed of two groups of elements arranged symmetrically opposite the diaphragm.

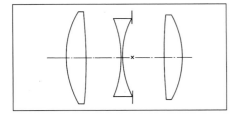

The triplet is a special type of anastigmat. The first triplet, introduced in 1894, had a speed of f/6.8 and was marketed under the name "Cooke Lens." A slightly modified form is frequently found in modern lens design.

In the accompanying diagrams, a single element represents the complete lens. As a convention, the light rays are always shown traveling from left to right (though they could just as well be the other way). And to keep things simple, the lens' refractive power and the wavelength of light are not taken into account in these diagrams.

A theory called Gaussian optics forms the basis of the equations used to calculate lens designs. Specifically, it explains how light rays in the "near-axis" area of the lens are brought into focus. This is the zone within which the light rays may be considered parallel to the lens' optical axis. The term "paraxial" is used to describe incoming light rays whose angles are so close to zero that they can be disregarded without jeopardizing accuracy.

As stated, Gaussian optics apply to paraxial rays in a limited area of the lens. With well-corrected lenses, however, these rules of optical design can be applied to equations and calculations concerning the complete area covered by the lens.

The image a lens or a single element creates is collinear, which means that each plane in the object space (i.e. the subject) is represented point-by-point on a corresponding plane in the image space (i.e. the film). The object space refers to everything on the subject side of the lens; image space includes everything on the film side.

Every element's center of curvature must be located on one straight line, which is defined as the lens' optical axis. Light rays proceeding on this optical axis pass through without being refracted (bent). All other rays will be refracted more or less strongly and may indeed follow quite a complicated path within the optical system.

To help you understand an image's geometric construction, every lens is assumed to have two principal planes aligned perpendicular to its optical axis. The points at which these two vertical planes intersect with the optical axis are termed the nodal points. There are two such intersections, logically called the front (object-side) and rear (image-side) nodal points. These principal planes and nodal points are the basis for determining the object and image distances and the focal length.

The object distance is the distance between the front nodal point and the object plane (normally the subject being focused on). Similarly, the image distance is the distance between the rear nodal point and the image plane (which is normally the film).

The focal length of a lens, which really refers to the back focal length, is the most important identification data. It is the distance from the rear nodal point to the focal point. The focal point is the

In 1892 the triplet was improved by changing the single rear element into two cemented elements. This Zeiss lens design is known as the Tessar.

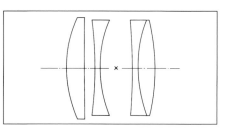

As early as the 1930s, the design of the triplet was advanced enough to allow speeds of up to f/1.5.

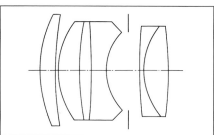

This diagram illustrates commonly used optical terms. Notice that the image created by a lens is reversed and inverted.
Diagram courtesy of Canon

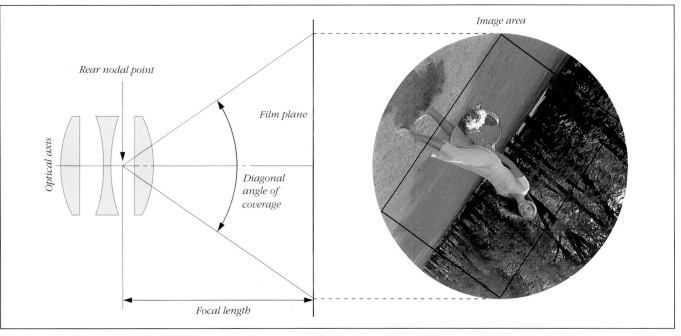

Image area

Rear nodal point

Optical axis

Film plane

Diagonal angle of coverage

Focal length

spot where light rays running parallel to the optical axis converge after passing through an optical system. The plane perpendicular to the optical axis passing through this focal point is called the principal focal plane.

Focal length is affected by a number of factors, including the thickness and curvature of the elements, types of glass, refractive indices, and the optical arrangement. The focal length of a lens determines its reproduction ratio, speed, and amount of extension required at any focusing distance.

Image Formation

A picture can only be formed when a "true" and recordable image is created in the image plane. This true image is projected by a collecting lens element or an optical system having an overall collective effect. Also known as a positive lens, the collecting element is convex—thick at the center and thin at the edge. Depending on their curvature, positive elements may be biconvex (convex on both sides), plano-convex (flat on one side), or concave-convex (concave on one side).

Unlike collecting lenses, dispersive ones are thick at the edge and thin in the middle. Common types include biconcave, plano-concave, and convex-concave. They are referred to as negative or diverging lenses because they produce a virtual or phantom image that cannot be recorded photographically. Nonetheless, dispersive elements are valuable in lens design, for they can be used to compensate for certain aberrations and also to change the focal length.

Aspherical elements, those which have a nonspherical curve to one surface, are a special case. Due to their varying curvature, these lenses are employed to correct specific problems or aberrations. (More detailed information will follow in later chapters.)

Refraction is of great importance in the formation of images. Inside a homogenous medium (such as air or glass), light travels in a straight line and at a constant speed. When light passes into a different transparent material, its traveling speed is changed, causing a deflection or refraction.

The junction between two surfaces, called the boundary layer, is where refraction takes place. Every lens element has two such boundary layers, each of which forms either a glass/air or glass/glass interface.

A ray of light reflected off the subject is deflected at each surface of the lens element according to the laws of refraction. When a ray of light passes into a denser material, it is deflected outward, away from the optical axis of the lens. If the light enters less dense material, it is deflected inward toward the axis. The degree of deflection depends on the material's refractive index and the light's wavelength. As mentioned earlier, light rays exactly in the optical axis are not deflected at all.

Modern Lenses

Today's lenses give superior overall image quality, with fewer optical aberrations than had been possible a few years ago. This improvement is mainly due to four advances: the use of high-powered computers in calculating optical systems, a superior range of glass types, better coating technology, and the development of aspherical surfaces. Still, it remains a complex and difficult process to create a superb lens, especially at extreme focal lengths and very high speeds. Perhaps that's why there are still considerable differences in image quality among lenses of various brands and types.

Lens Design

Now, lens manufacturers use computers when designing new lenses. Powerful processors and special software allow a lens' properties to be simulated long before the first prototype exists. Even manufacturing tolerances during the production run can be taken into account.

Despite all this technology, a company's accumulated knowledge still plays an important role, especially when it comes to high-end lenses. In addition, even the image quality of various classes of lenses within the same manufacturer's range may differ quite substantially.

These differences represent an inevitable compromise between the degree of optical and mechanical quality desired, and the cost of production. A company can't simply design and manufacture exceptional lenses free of every aberration; it has to sell them at a price the market will bear.

Lens aberrations can be divided into two categories: monochromatic and chromatic. The monochrome aberrations (spherical aberration, coma, astigmatism, and curvature of field) show themselves as a lack of definition and as linear distortion. Chromatic (color) aberrations, caused by dispersion, are visible as separation (longitudinal chromatic aberration) and color fringing (lateral chromatic aberration).

Before computers were used extensively in lens design, calculations were done according to Seidel's rules, which are only valid for the paraxial zone and for small picture angles (as discussed in the previous chapter). Therefore, extreme wide-angle and high-speed lenses could not be sufficiently corrected. Modern computer-aided design systems are capable of recognizing off-axis aberrations throughout the image plane, compensating for optical errors in lenses of all types. In addition, a

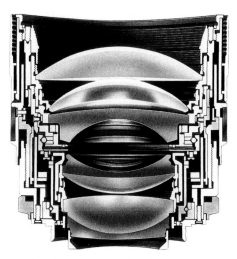

Modern lenses are examples of precision mechanical and optical construction as illustrated by this cross-section of a Leica Summilux-R 80mm f/1.4 lens.

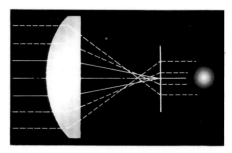

Light rays refracted through a spherical lens element will focus closer to the lens the farther they are from the optical axis. As a result the image is blurred.

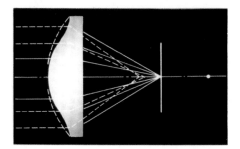

Using an aspherical element brings both the off- and near-axis light rays to a common focal point.

Optical glass smelted according to special formulas is the prerequisite for high-quality image rendition.

Precision grinding and polishing results in crystal-clear, flawless lenses and prisms.

computer can calculate lens contrast levels and diagram the complete bundle of rays passing through the exit pupil.

Some aspects of lens design, however, have not changed. For example, calculations are still done element by element, from one surface to the next. Cemented groups are treated as if they were a single element. And data for every element and surface is entered into the computer separately. This procedure applies to mirror lenses as well, since reflected light may be considered to be a special case of diffraction.

Lens design can be optimized for a particular kind of use, which may dictate the reproduction ratio (and focusing distance) at which the lens offers peak performance. Most conventional lenses are corrected to reach their maximum optical effectiveness at infinity. Studio lenses, however, are designed for use at approximately 1:10 ratio (1/10 life-size image on film), and macro lenses are optimized for the range from 1:5 to 1:2 or 1:1. Despite these "peaks," well-designed lenses tend to produce very good image quality throughout the focusing range.

Optical Glass

Optical glass includes a variety of glass types with specific properties. All are made from smelting together mainly silicic acid (quartz sand), metal oxides (lime and lead compounds), and alkaline earth metals (sodium and potassium compounds). The properties of optical glass can also be controlled precisely by the use of additives such as lanthanum, molybdenum, tungsten, thorium, tantalum, barium, cadmium, or zinc.

The different types of optical glass are classified according to their levels of refraction and dispersion. Refraction is a change in the speed and direction of light waves when they pass through the boundary layer of an element. A refractive number or index is a constant describing the effect a material has upon light waves traveling through it. (By definition, a medium's refractive index is the ratio between the speed of light in a vacuum and in the medium itself.)

Optical glass is available with indices from 1.45 (soft crown) to 1.96 (dense flint). The amount of refraction is not only determined by the material but also the light's wavelength, since different wavelengths travel at differing speeds. However, whatever the medium, short-waved blue rays are diverted more than long-waved red rays.

The separation of light into its spectral components when passing from one medium into another is called dispersion. Depending on its refractive index, an optical medium's degree of dispersion is indicated by its "Abbe's number." A large amount of color separation (dispersion) is characterized by a small Abbe's number, and vice versa.

The first types of optical glass were developed toward the end of the last century by Ernst Abbe and Otto Schott in Jena, Germany. In the beginning only crown and flint glass were available. Crown glass displays weak refractive power and a large amount of dispersion, while flint glass offers strong refractive effects and low dispersion. These opposing properties are the reason why different types of crown and flint glass are employed together to compensate for certain aberrations.

Newly developed extreme glass variants having both a high refractive index and low dispersion allow

even better correction of chromatic aberrations. Depending on the manufacturer, they are termed LD-, ED-, or UD-glass (low, extra-low, or ultra-low dispersion) and used in apochromatic or near-apochromatic lenses. Glass with extremely low dispersion is created mainly by adding lanthanum and other alkaline earth metals.

Optical glass must meet extraordinarily high quality standards. It must be free of bubbles and striations, as transparent as possible, and capable of true color rendition. Producing such glass is a complex process. The ingredients, which should be absolutely pure, are first pulverized and thoroughly blended. Then the mixture is carefully heated up to 1500° Celsius in specially designed platinum or quartzite crucibles within inductive or smelting furnaces.

The molten material is annealed and cooled for several weeks, according to exact specifications. This stringently controlled slow-cooling procedure prevents strains from developing within the glass, which could lead to cracking during later processing. (Strained glass can be identified with the help of polarized light.) Also, only strain-free glass is isotropic, meaning that it displays the same amount of refraction throughout. Finally, the glass' internal structure is influenced by the cooling process, which decisively determines its refractive index.

There are two ways to form individual elements. While still hot and soft, a blank can either be cut from a continuous rod or pressed into a shape closely resembling the intended final surface. Then the blank is milled, ground, and polished.

Some manufacturers have begun to use plastic or "organic glass" elements in recent years. These inexpensive elements have distinctive attributes: Polystyrene has properties similar to flint glass, and polymethylmethacrylate can be compared to crown glass. The current array of "organic glass" is limited, making it difficult to design well-corrected lenses with only plastic elements. Plastic elements are also not generally suited for top-quality lenses because they tend to be softer and more delicate than optical glass, and also tend to expand more when they get warm.

Lens Coatings

Inevitably, some of the light arriving at the boundary layer between two media is reflected. Each of an element's glass-air surfaces represents such a boundary layer, so there are several of these glass-air interfaces in every lens. Every glass-to-air transition causes a loss of light due to reflection (or partial reflection, to be precise); depending on the glass' refractive index, this can between 4 and 8%.

Light rays reflected from surfaces inside the lens are deflected toward other surfaces, which in turn reflect a percentage of them again and again. This results in stray light (flare) arriving at the image plane and reducing contrast rendition by fogging. Thus, every single reflection decreases image quality. In a lens consisting of multiple elements, the reflections from the glass-air surfaces could add up to a considerable loss of light, image deterioration, and flare.

Fortunately, lens reflections can be reduced considerably by coating the surfaces. Such coatings consist of one or several layers (multi-layer coating), each made of magnesium fluoride or other halides applied to

Before the computer-controlled multi-layer coating is applied, the elements must be thoroughly cleaned in an ultrasonic bath.

The multi-layer coating is applied in a computer-controlled vacuum unit.

The lenses are tested and cleaned in what are known as "ultra-clean rooms."

Computers assist in centering the lens elements perfectly.

An interferometer is used to test the finished lens.

the elements' surfaces by vaporization in a vacuum chamber.

The thickness of each layer must be equal to exactly 1/4 the wavelength of light it is supposed to prevent from being reflected. Therefore a single layer can only stop the reflections caused by a single wavelength. With every additional layer of coating, reflections will be eliminated over a broader spectral range.

Also, coatings can be used to correct for "warmer" or "cooler" color rendition caused by different types of glass and variations in lens design (such as the number of elements).

Theoretically, every additional layer of coating should reduce reflections and enhance transmission. But in reality, adding more layers does not always improve image quality. Each layer has a certain light-absorbing effect, so total transmission may be significantly reduced, particularly with comparatively thick layers. This is another reason why coatings must be an integral part of lens design, matched to every type of glass and factored into the computer calculations.

Major Lens Components

Modern lenses for 35mm cameras are small master-pieces of precision optics, mechanics, and (increasingly) electronics. They are built from hundreds of complex parts, produced and assembled to precise specifications. The following chapter describes the most important lens components, to enable you to make wise choices in selecting and using your own lenses.

Bayonet Mount

The bayonet mount is the vital link between an interchangeable lens and the camera body. Both the bayonet on the lens and its socket on the camera must be machined to very high accuracy in order to ensure that the lens axis is exactly perpendicular to the film plane at all times. Perfect fit also ensures that the camera's and lens' mechanical and electrical operations are maintained by a properly functioning signal-transfer system.

Bayonet components on the body and on the lens should be made of the same material, such as brass with a tough chrome plating. If different alloys are employed, they must be carefully matched and have the same coefficient of thermal expansion. High-end camera and lens bayonets should be robust enough to withstand decades of use, involving over 100,000 lens changes, without wear reducing their precision fit.

The bayonet's inside diameter must be sufficiently large to prevent any vignetting of the picture edges or corners when using long focal lengths, or long lens extensions for close-ups. Many lens bayonets are connected to a knurled ring, ensuring easy and secure lens changes with their positive grip.

A raised dot on the camera mount indicating proper lens alignment is a desirable feature for shooting in low-light conditions. Well-designed lenses can be changed with one hand and have no prongs or other controls protruding beyond the bayonet, which may be damaged when fitting onto the camera or if the lens is put down without its back cap.

The construction of the bayonet mount is of major importance because it serves as the interface between the camera body and the lens.

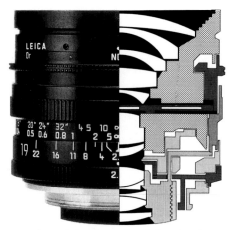

A wide-angle lens has a short helicoid and barrel.

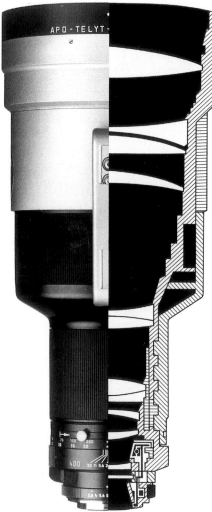

A telephoto lens requires a long helicoid and barrel.

Usually, lenses make a definite audible click when rotated to the locked position.

One of the most crucial dimensions of the camera is the distance between the face of the bayonet mount and the film plane (the flange-to-film plane distance). The slightest change to this distance, or damage to the flange, will lead to major focusing problems, especially at infinity. Overall sharpness at the widest aperture will suffer if the flange is not absolutely parallel to the film plane. The bayonet must always be aligned perfectly to ensure the correct flange-to-film plane distance and remain so even when subjected to extreme mechanical stress by frequent lens changes.

Lens Barrel

For a lens to deliver optimum performance, the glass elements must be precisely mounted in the barrel, centered, and locked at just the proper positions. The more accurate the centering, the higher the lens' image quality will be.

Lens construction must also remain absolutely rigid at all operating temperatures. The barrel and the helicoid should both be constructed of materials that are insensitive to temperature variations. If all parts are made of the same materials, with similar expansion coefficients, smooth and easy focusing will be ensured at all times. The helicoid components are ground to mate together perfectly, which demands very tight production tolerances. In addition, the interior of the barrel, and every other internal structure, must be specially designed to absorb as much stray light as possible, and coated with matte-black paint.

To ensure smooth focusing

movement, a special grease is used to lubricate the helicoid. This material maintains its lubricating properties in extreme temperatures and continuous operation yet will not harden during periods of non-use.

The torque required to turn the helicoid and move the lens barrel is an important function in the overall design of a lens. A straight in-and-out movement of the lens barrel is best, with a non-rotating front end to simplify the use of polarizing, graduated neutral-density, and special-effects filters. Once set, their position and effect will be unchanged while focusing the lens.

Plastic barrels and tubes are often employed in autofocus lenses because the lighter material can be moved more quickly by the AF motor. Unfortunately, there may be a trade-off in durability. Like a metal bayonet mount, a metal barrel's superiority can be seen in direct comparison with its plastic counterparts. High-quality lenses employing metal barrels allow the optical elements to be centered more accurately than plastic tubes. Metal barrels can also be subjected to much harder use and still maintain their precision after decades of use. It still remains to be seen if the same can be said of plastic-barreled lenses.

Diaphragm

The diaphragm is a mechanical device built into most 35mm lenses. Modern photographic lenses almost exclusively use iris diaphragms consisting of multiple crescent-shaped blades that produce a symmetrical opening centered on the optical axis of the lens. Varying the size of the opening, or aperture, controls the amount of light entering the camera.

Aperture size is measured as a fraction of the focal length and is expressed as an aperture ratio. A ratio of 1:8 indicates an aperture opening eight times smaller than the focal length of the lens. The ratio's reciprocal value is the *f*-number, *f*/8 in our example. Note that the larger the *f*-number, the smaller the aperture opening.

F-numbers are engraved on a click-stop ring on the lens. In practical photography it is useful if the aperture ring indicates half-stops as well. Depending on the operating mode selected, the aperture is either set manually by the user or automatically by the camera.

The diaphragm should be designed and built to meet stringent demands. It must close accurately and repeatedly to the predetermined value, thousands of times, and at all temperatures. The blades need to close quickly and arrive at each designated position with a minimum of bounce. Naturally, the diaphragm blades should be black to suppress reflections and stray light.

Distance and Depth-of-Field Scales

To achieve sharp pictures, the image must be focused accurately on the film plane. Therefore, viewfinders of 35mm cameras offer various focusing aids such as a split-image rangefinder, matte Fresnel field, or electronic focus indicator.

Whether set manually or by the AF system, the focusing distance can be read off a scale on the focusing ring. Distance settings are usually indicated in feet as well as in meters. The distance position for infinity is represented by a symbol resembling a horizontally placed figure eight, also marking the end

of the helicoid's rear travel. (To allow for temperature-related variations, some telephoto lenses can be rotated beyond the infinity mark.)

The distance scale's most useful function is to allow the user to determine depth of field. Many lenses have a second scale engraved on their barrels, consisting of pairs of *f*-numbers situated symmetrically around an index mark. With the help of this scale, the photographer can discover the zone of sharpness resulting from a particular distance setting and aperture value.

The same scale also permits you to set the hyperfocal distance, which gives the greatest possible depth of field for a given lens aperture. To do so, align the infinity mark on the focusing ring to the number on the depth-of-field scale corresponding to the chosen *f*-stop. The total depth of field, as displayed on the focusing ring, extends from infinity to the distance shown by the corresponding aperture number on the other side of the index mark. Hyperfocal settings are especially important with 35mm and medium-format cameras, which generally do not allow control of depth of field by swinging and tilting the front and rear standards, as do large-format cameras.

Also found on some depth-of-field scales is an infrared focusing mark. Because infrared radiation focuses at a different distance than visible light, images shot with infrared film would be blurry if a focus adjustment were not made. To focus when shooting with infrared film, set focus visually. Then align the focusing distance with the infrared focusing mark (usually a short line or dot.) However, it should be considered only to be a general reference point for infrared photography.

Highly accurate machining of lens tubes and barrel parts to minimal tolerances is a prerequisite for an excellent lens.

The expansion coefficients of the materials used for the tubes and helicoids should be nearly identical.

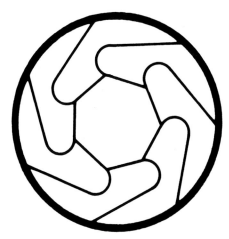

This illustrates the construction of a standard iris-type diaphragm construction with seven leaves.

The depth-of-field scale on a manual focus lens

Autofocus Components

Regardless of the operating system, any autofocus system requires a motor to drive the helicoid in the lens. This AF motor can be situated in the camera body or the lens itself. When built into the body, it drives the lens' gear train with a shaft that runs through the bayonet mount.

Several zoom lenses offer motorized or "power" zooming, facilitated by a separate zoom motor. Many newly designed lenses are also fitted with an 8-bit microcomputer responsible for the exchange of data between the camera and lens. Some lenses use specially designed miniature motors in the lens to operate the diaphragm.

The depth-of-field and distance scales on an autofocus lens

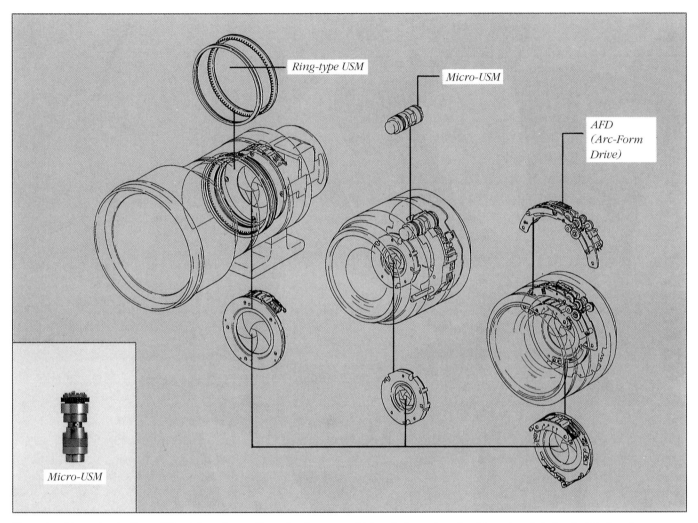

Ring-type USM

Micro-USM

AFD
(Arc-Form
Drive)

Micro-USM

The motor drive system in Canon EF autofocus lenses. Canon produces several types of ultrasonic motor drives: ring-shaped, cylindrical, and arc-shaped. Canon's Micro-USM has already replaced the original arc-form drive (AFD) in more than 20 EF lenses. Automatic focusing with the Micro-USMs is faster and quieter than with the AFDs. The cylindrical Micro-USM is smaller, lighter, and considerably cheaper to produce than the ring-shaped USM.

Lens Characteristics

A lens' characteristics, such as its focal length, image area, angle of coverage, and speed (determined by its maximum aperture), combine to determine under what conditions it can be used and ultimately the look of the resultant photograph.

All major camera and lens manufacturers list a wide range of lenses in their catalogues; all are described by their focal lengths and apertures. This picture shows a selection of autofocus lenses available from Nikon.

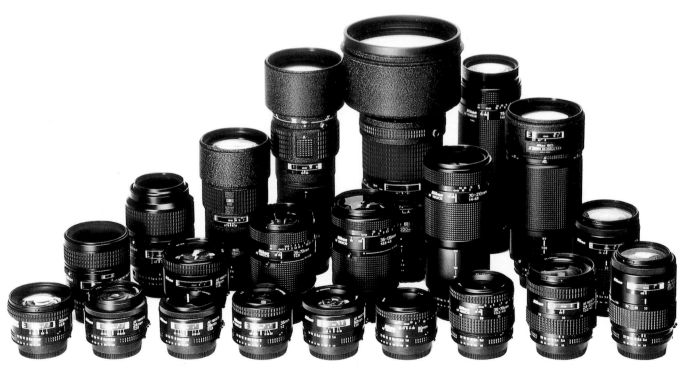

In 35mm and medium-format photography, a lens is identified by its focal length and maximum aperture. These are constant factors. For shift or large-format lenses, image area is another important factor. When describing a focal length, its picture angle in relation to the particular film format is also vital.

Focal Length

A lens' focal length is probably its most important specification. It is designated in millimeters and engraved on most lens models; the previously popular identification in centimeters (or even inches) is only found on old lenses.

Earlier in this book it was explained that every lens has two focal lengths, one in the image space and the other in the object space. Consequently, there is a back and a front focal length. Whenever a lens' (or an element's) focal length is stated, however, it always refers to the back focal length.

Focal length is crucial in determining a lens' reproduction ratio, extension, and speed. Along with the camera-to-subject distance, the focal length determines how large an object will appear in the image. When used from the same distance, lenses of identical focal length always record the same object at the same image size, regardless of the film format. For example, from a distance of 50 feet (15 meters), a lens with a focal length of 180mm records a particular object on film as 21 mm high, whether the camera format is 35mm, 6x7 cm, or even 8x10 inches. The only difference is that with each larger format, more of the surrounding area will be included in the image.

Reproduction ratio is also proportional to the focal length. If the lens-to-subject distance remains the same, doubling the focal length will double the reproduction ratio. So, from a given distance, a 50mm lens records a certain object at a height of 12 mm, a 100mm lens will image the same object at a height of 24 mm, while the image from a 25mm lens will measure only 6 mm. This statement refers to the picture format's linear dimensions, width and height. If you change from a 50mm lens to a 100mm, you double both the width and the height of the image, thereby quadrupling its size. Despite common misunderstandings, perspective is not determined by the focal length in any way.

Designating a certain lens as a normal, telephoto, or wide-angle is always done in reference to the diagonal of the film format in question. Generally speaking, a normal lens is approximately equal to the film diagonal (43.3 mm for the 35mm format). Longer focal lengths are considered telephotos; shorter ones are wide-angles. Therefore, a 90mm lens would be considered a short telephoto for the 35mm format but a normal focal length for the 6x7 cm format.

By convention, 50mm is now considered the normal focal length for 35mm cameras, although older models had normal lenses from 40mm to 58mm. In the 35mm format, focal lengths of 35mm or less are considered wide-angle, while those over 70mm are recognized as telephoto. These categories are useful in describing the general relationship between lenses of varying focal lengths. In later chapters, each type of lens will be considered in relation to its own practical applications.

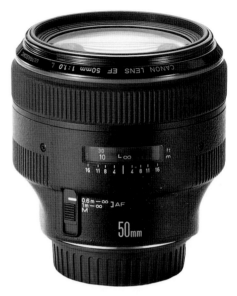

An exceptionally fast lens: The Canon EF 50mm f/1 L USM lens

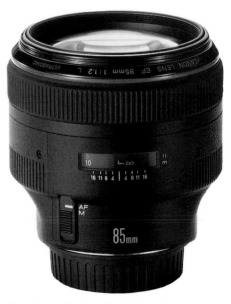

The Canon EF 85mm f/1.2 L USM lens

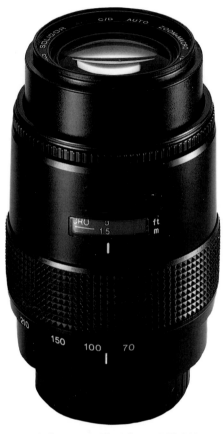

A telephoto zoom: The Soligor AF 70-210mm f/4-5.6 lens

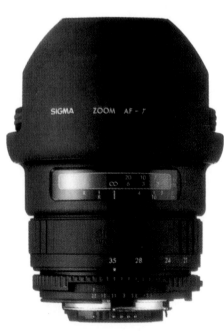

A wide-angle zoom: The Sigma AF 21-35mm f/3.5-4.2 lens

Image Area and Angle of Coverage

Every lens generates a circular image on the film plane, which deteriorates in definition and brightness toward its edge. This circle is called the image area, and it is usually measured with the lens focused at infinity. The portion of the image area that is rendered sharply is termed the circle of good definition. This circle is very important for shift lenses or large-format cameras, because it defines the maximum possible shift and tilt.

Stopping down the aperture improves the definition at the edges of the image circle. The circle of good definition also grows in size as the lens extension increases for close-ups. Within this circle is the actual picture format, a square or rectangle determined by the camera's picture gate.

Even among professionals, it is common for the term angle of coverage to be misunderstood, perhaps because it can refer to several different values. Angle of coverage or picture angle is derived from the lens' focal length and the film format. In 35mm photography, a lens with a focal length of 21mm has a picture angle of 92°, while a 135mm lens has a picture angle of only 18°. Lenses with picture angles larger than about 50° are called wide-angles; those with picture angles smaller than about 40° are telephotos.

On some data sheets, the horizontal and vertical picture angles of a lens are also listed. They relate to the width and height of the picture format, respectively. When comparing several picture formats with different aspect ratios (i.e. ratios of width to height), this data might become misleading. In any case, it is best to begin evaluations with the diagonal picture angle.

Lens Speed

Another characteristic of a lens is its "speed" or largest aperture. As mentioned earlier, the aperture is the ratio of the entrance pupil's full diameter to the lens' focal length. In simple terms, the aperture is the diaphragm opening that can be seen (and measured) when looking into the lens through its front element.

If a lens with a focal length of 90mm has an entrance pupil diameter of 45 mm, the aperture ratio is 1:2, usually expressed as $f/2$. For this to be so, the diameter of the front element has to be at least 45 mm. Again, the aperture ratio indicates the lens' maximum speed at the diaphragm's largest opening; it is indicated by the smallest f-number.

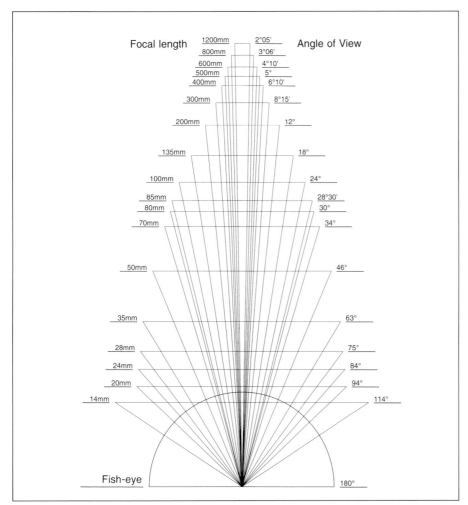

Focal length — Angle of View

1200mm	2°05'
800mm	3°06'
600mm	4°10'
500mm	5°
400mm	6°10'
300mm	8°15'
200mm	12°
135mm	18°
100mm	24°
85mm	28°30'
80mm	30°
70mm	34°
50mm	46°
35mm	63°
28mm	75°
24mm	84°
20mm	94°
14mm	114°
Fish-eye	180°

This diagram illustrates the relationship between the angle of view of a lens and its focal length. Although the principle is the same for other formats, the specific angles noted here apply only to the 35mm format.

A wide-angle: The Yashica ML 28mm f/2.8 lens

A fast telephoto: The SMC Pentax 600mm f/4 ED IF lens

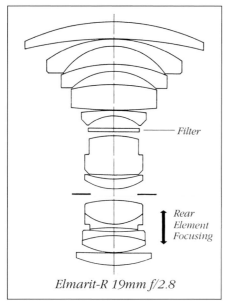

Filter

Rear Element Focusing

Elmarit-R 19mm f/2.8

Technical data on a lens' optical system, such as the number of elements and how the lens is constructed, can usually be found in its instruction manual.

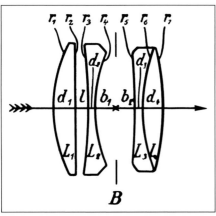

This technical illustration of the Zeiss Tessar is taken from the 1903 patent description.

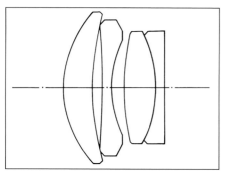

A cross-section of a modern Tessar-type lens

The term speed is somewhat misleading, as it refers to a purely mathematical or geometrical value that disregards the amount of light actually transmitted by the lens. Loss of light caused by absorption and reflection inevitably reduces the effective aperture.

In high-quality lenses, these losses are minimized, so the marked maximum aperture is a good indication of the effective aperture. At the low end, however, there have been lenses showing a deviation between the two values of up to one full stop, so a lens with a marked aperture of $f/1.4$ actually had an effective aperture of $f/1.9$ or $f/2$. Cameras with through-the-lens metering systems automatically compensate for variations in light transmission. However, the required shutter speed will be slower to make up for the loss of light.

Lens Technical Data

Manufacturers' brochures usually contain technical data that can be helpful in evaluating a lens. Depending on the intended application, some specifications may be of great importance, while others are of little meaning to a photographer.

Some manufacturers emphasize the number of elements and groups in a lens, suggesting that more glass means higher quality. For example, a lens designed with 16 elements in 12 groups seems quite impressive. But the number of elements and groups actually gives little indication of image quality. Don't let this information sway you.

The minimum focusing distance and maximum reproduction ratio are vital specifications for shooting close-ups. Just because a lens is capable of rendering an image at a ratio of 1:5, however, implies nothing about its performance at close distances. With the exception of true macro lenses, most lenses are corrected for best image quality focused at infinity. A zoom lens may include "macro" in its name, and have an extended focusing range, yet be poorly suited for precision close-up work.

The minimum aperture (largest f-number) indicates how far the diaphragm can be stopped down to gain maximum depth of field at a given reproduction ratio. This may be important for landscapes, close-ups, and other subjects that require extensive depth of field. One caveat: Particularly with short lenses, use of apertures smaller than about $f/8$ reduces image quality, due to refraction caused by the edges of the diaphragm blades.

Filter size information should at least help you avoid purchasing filters with incorrect diameters. Ideally, all of your lenses will have the same thread size, but it is seldom worth choosing one lens over another just because of filter size.

Other design parameters include floating elements (to improve image quality at close range), internal focusing (to keep lens length constant during focusing), and a non-rotating front element (to maintain a fixed filter orientation during focusing). This information is sometimes omitted from the technical data, but it can be quite relevant to the evaluation of a particular lens. Further specifications of length, diameter, and weight are of interest to travel, landscape, and nature photographers who have limited space and/or must carry equipment for extended periods.

Optical Performance and Quality Control

A lens should create a sharp, undistorted image with accurate color rendition. To do so, its aberrations must be corrected to a high standard of quality. Unfortunately, aberrations can never be eliminated completely; every lens displays some faults that may impair its performance to some extent. Only a few aberrations, such as distortion, appear independent of all the others. The remaining flaws usually overlap each other, accumulating into a general falloff of image quality toward the edges and an overall lack of contrast.

The Decisive Edge

In spite of computer programs and modern methods of design and manufacture, it's surprising to see how many current lenses have poor optical performance. Naturally, the manufacturer's knowledge and quality-control standards influence a lens' design drastically. The lens designer's objective is to produce a lens that achieves the best compromise between the degree of correction desired and the proposed selling price. Comparing price and quality is a normal exercise before every purchase, and of course, photographers want to buy a high-grade lens as inexpensively as possible. However, the following important point is rarely taken into consideration:

If the maximum possible degree of correction were 100%, it would be fairly easy to improve a given lens' correction from 60% to 80%.

At this level an improvement of 20% can be achieved at a moderate cost, using standard techniques and materials. But let's say the manufacturer wanted to improve a particular lens from 90% correction to 95%. This would demand very complex design calculations and the use of expensive types of glass with unusual optical properties. The 5% advance in image quality could only be realized with a huge expenditure of resources and effort, which could increase the price by 30% or even 50%.

Correcting fast lenses is a good example of this process. The large diameter of the lens' elements amplifies the main aberrations, which demand even greater correction efforts. Therefore, a 35mm lens with a maximum aperture of $f/1.4$ is considerably more expensive than one of similar quality with an aperture of $f/2$ or $f/2.8$.

To help you evaluate lens

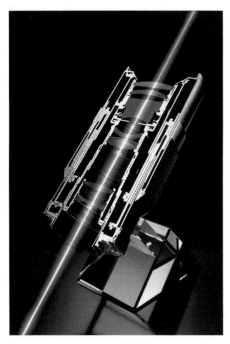

A laser beam is often employed to perform lens tests with a modulation transfer function (MTF) meter.

performance, several relevant factors are described in this chapter. Due to space limitations, the explanations must be kept simple. Note that some of the tests mentioned, such as MTF, are too elaborate to be performed at home. Their results are seldom included in manufacturers' literature but are available in some photo publications.

Resolution

A lens' (or film's) resolution—also called resolving power—is its ability to reproduce the subject's smallest details, no matter how close to each other they are situated. Resolution is usually specified in line pairs per millimeter (lp/mm). It is measured in an absolutely vibration-free room, where a test target consisting of gradually diminishing shapes (line patterns, grids, numbers, stars, or hexagons) is photographed under strict lighting and contrast conditions.

The resolving power of the lens or film under test is the number of separate line pairs that can be seen clearly on the test-target negative. Theoretically, the finest lenses can resolve up to 800 lp/mm. These values, however, are never achieved in practical photography and can only serve as a comparison or reference point. Also, many factors affect image quality, so resolution alone is not a sufficient basis on which to judge a lens.

In actual applications, several factors will reduce theoretical resolving power considerably. These include low subject contrast, camera shake, subject movement, inaccurate focusing, and imperfect film flatness. Photographers may encounter multiple factors in one image, such as diffused lighting, slight overexposure, and diffraction

from a small lens opening.

The theoretical resolving power of a lens may be reduced by a factor of 10 or 15, for several less-obvious reasons. First of all, these values are recorded at the center of the picture, without considering the falloff at the edges. Next, this resolution figure is quoted with the lens at full aperture, and the maximum achievable resolution is continually reduced at smaller apertures. It may seem odd, but theoretical resolution is highest with the lens wide open; as the aperture stops down, definition is limited by diffraction. For example, if a lens displays a resolution of 800 lp/mm in the image center at $f/2$, only about 200 lp/mm will remain at $f/8$, and just 72 lp/mm can be read at $f/22$.

Contrast Rendition

A lens' (or film's) contrast range is its ability to reproduce the subject's contrast, which has a decisive influence on the impression of sharpness in a picture. Photo-lab technicians make use of this fact by copying slightly out-of-focus negatives on "hard," contrasty paper to improve the pictures' definition.

Image contrast is, of course, strongly affected by the contrast rendering of the lenses involved. (The plural is used because you have not only a camera lens, but one on the enlarger or projector). To achieve a high level of contrast, you need a lens with well-corrected aberrations and a minimum of internal reflections.

Contrast is also influenced by several related factors, including the subjects' inherent contrast, the contrast level of the lighting, and the amount of color contrast present. The final result can be altered by the film and paper used,

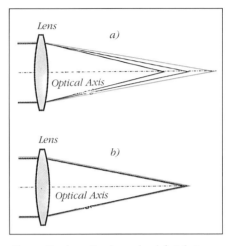

Chromatic aberration is a color defect that occurs due to the refractive index of the optical glass changing the wavelength of the light as it passes through the glass.
a) Longitudinal color defect: Short-wave blue rays are deflected more strongly than medium-wave green rays and long-wave red ones.
b) Apochromatic correction: The three primary colors have a mutual focal point.

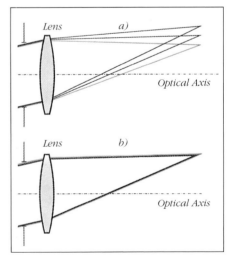

a) Transverse or lateral chromatic aberration becomes visible in the case of inclined rays of light. This off-axis flaw causes color fringing, which worsens with an increase in focal length.
b) It is usually corrected only in high-grade lenses.

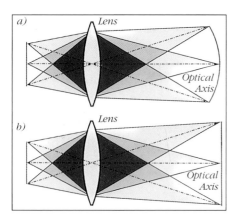

a) If the subject plane is recorded as a curved surface, this is known as curvature-of-field. The result is that only the center or the edges appear sharp in the image plane.

b) The effects of curvature-of-field can be reduced by lens correction or stopping the lens down; increasing the depth of field will more or less "cover" the lack of definition.

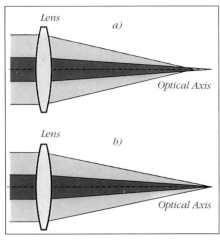

a) Spherical aberration is caused by the spherical surfaces of the lens elements bending the light rays more at the edges of the element than at the center.

b) Correcting this is most difficult for fast lenses and lenses with long focal lengths.

the type and amount of development, and the design of the enlarger (especially its light source and condenser). Even the image format and reproduction ratio can have an impact.

The impression of sharpness is achieved by a combination of contrast rendition and resolving power; it cannot be provided by either one alone. So to properly evaluate image quality, you need to measure resolving power in relation to contrast. The test that achieves this is called a modulation transfer function (MTF), and it will be described in greater detail later in the chapter.

Reproduction Ratio

The relationship between the size of the image and the size of the subject is the reproduction ratio. This ratio depends on the focal length of the lens and the camera-to-subject distance. In many cases, image quality (as measured by the modulation transfer function) is influenced by the reproduction ratio. Especially in the case of very asymmetrical lens designs such as retrofocus wide-angles, MTF results at different reproduction ratios can vary widely. That's why floating elements are often employed to improve lens performance at close range. Ideally, a lens' MTF should be consistent at all reproduction ratios.

The influence of reproduction ratios on image sharpness is not widely known, because it is rarely discussed in photographic literature. For example, the reproduction ratio governs the size of the details in the picture. This in turn affects the contrast range, which is vitally important for the impression of sharpness. MTF tests show that the smaller the details are on film, the poorer the contrast rendering, and the lower the picture's definition.

In practical photography, smaller formats are affected by this more than larger ones. For example, a box of chocolates will be seen at four times the reproduction ratio on a 6x7 cm negative than on a 35mm frame, assuming that the image fills the frame in each case. The details on the box would also be four times as large in the 6x7 format and the enlargement factor four times less. The result would be an obviously sharper picture in the larger format.

Modulation Transfer Function (MTF) Testing

Photographers frequently question the quality of photographic systems and lenses. Presently, the best answers are provided by the modulation transfer function test. As mentioned earlier, the MTF test offers a true measurement of an optical system's image quality by evaluating resolving power in relation to the contrast range.

A grid consisting of very thin black lines, separated by an equal

number of identically sized transparent lines, serves as the target. The size of these grids is given in line pairs per millimeter (lp/mm), called the spatial frequency. The test pattern is illuminated from behind with diffused light, and its level of brightness confirmed with a microdensitometer. Because of diffraction occurring at each edge, the light's intensity changes gradually rather than abruptly from the dark to the light zones. The difference in the light rays' intensity between bright and dark is called modulation, which in this case is identical to contrast.

The recurring changes between bright and dark (called oscillation) are measured at several points on the test grid, as well as at the image plane. Then the readings are compared. The MTF test thus reveals how much of the subject contrast, which is always considered to be 100%, is reproduced at the image plane. High percentages of contrast indicate a lens with good image quality.

The MTF is performed with the test grid arranged sagittally (parallel to the image-area radius) and tangentially (perpendicular to the image-area radius). Because the light ray paths become increasingly uneven toward the picture's edges, the two results can differ considerably. It is therefore advisable to include off-center tests with the line grid placed diagonally (at a 45° angle to the image-area radius). Finally the MTF is tested at different spatial frequencies, at varying

image heights within the image area and with the patterns arranged differently.

Zoom lenses should be tested at minimum and maximum focal lengths, and also at intermediate points, potentially producing hundreds of individual results. This extensive evaluation is desirable because MTF tests are only valid for one measuring point, one spatial frequency, one aperture, one reproduction ratio, one color of light (wavelength), and one orientation of the line grid. Because of these variables, the results of MTF tests cannot be condensed into a single value. Instead they are expressed in several image-definition numbers, which together describe a lens' performance.

A particular lens may produce excellent sharpness in the center of the image, but deteriorate strongly toward the edges. Another may show slightly less quality in the center, but a much more uniform definition across the whole image field. The test results can be expressed in absolutely objective terms, but only the photographer can decide which one is preferable in actual use.

MTF tests allow lenses of various types, brands, and models to be directly compared to each other. Test results are then shown in diagrams and tables. While the image-definition numbers are impartial, the difference between one number and the next represents a barely visible distinction in image quality.

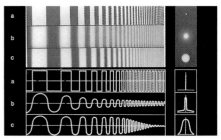

Examples of how a rectangular grid's Modulation Transfer Function (MTF) can be illustrated:
a) the ideal, theoretical reproduction
b) high resolution power
c) high contrast rendition

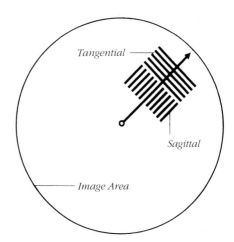

Tangential and sagittal arrangement of the line grids in MTF tests

Part of the MTF lens testing apparatus

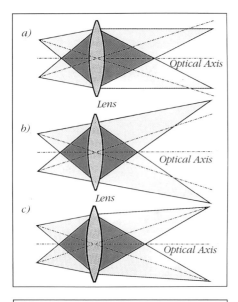

Distortion makes straight lines appear curved. It is caused by the subject not being reproduced at the same magnification ratio across the entire image field.

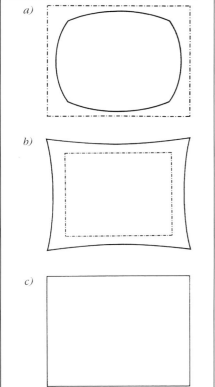

The reproduction of a rectangle:
a) Barrel distortion
b) Pincushion distortion
c) Distortion-free picture

Other Aspects of Quality

MTF testing offers an accurate assessment of definition by evaluating the level of uncorrected defects such as coma, astigmatism, and chromatic and spherical aberrations. To determine overall lens performance, however, you must also measure the amount of vignetting and distortion and the spectral transmission.

Every lens suffers a loss of light toward the edge of the image circle, known as vignetting. So-called "natural" vignetting is unavoidable, as defined by the laws of optics, specifically the cosine law of illumination. Artificial vignetting, however, is caused by lens design and is usually more obvious. It occurs when the lens barrel and/or the exit pupil cuts off the light rays' path.

Both types of vignetting are taken into account when the light falloff of a lens is being measured. Normally, such tests are carried out at full aperture and then repeated with the diaphragm closed by two stops. (Vignetting tends to be reduced at smaller openings.) For most applications, a brightness loss from center to edge of 1/3 stop or less is acceptable.

Distortion is a defect that spoils the subject's geometry by causing rectangles and straight lines to be reproduced in a pincushion, barrel, or wavy shape. The type and amount of distortion depend on the reproduction ratio, the lens focal length, and the optical design. Distortion can be measured precisely, and even a small amount may have an adverse effect, especially in architectural photography. Generally, zoom lenses distort more than fixed focal length lenses, and wide-angle lenses more than normal and telephoto lenses.

Color transmission is another facet of image quality. As mentioned earlier, some of the light passing through optical glass is lost due to absorption and reflection at the lens-element surfaces. These transmission losses are determined by the light's wavelength (color) and the type of glass involved. In particular, modern highly refractive glass, such as the ED variants, bends light much more strongly at certain wavelengths. This can distinctly affect a lens' color rendition, unless it is offset with measures such as sophisticated lens coatings.

Keep in mind that these are general statements, and exceptions to the rules are many. On the other hand, they are based on many years of professional evaluation of MTF tests, as well as measurements concerning vignetting, distortion, and transmission. Comparisons in practical, everyday photography have led to similar conclusions.

Alternative Testing

Together with MTF tests, measurements of vignetting, distortion, and color transmission permit an accurate description of a lens' performance. The results can then be confirmed by in-use tests, although these may be hampered by familiar problems such as poor film flatness, low subject contrast, imprecise focusing, and camera shake. Diffraction caused by small diaphragm openings can also reduce image quality. This will occur in all tested lenses in a similar manner, however, so the differences between them will remain.

Photographers who use color negative films to make prints up to 8x10 inches can safely do without tests, since the differences in image quality will not be noticeable at these small enlargements. Those shooting color slide films or producing larger prints (black-and-white or color) should definitely evaluate their lenses' image quality. This is even more important for professional photographers whose pictures must meet the highest requirements.

Many photographers try to evaluate their own lenses by setting up test targets or shooting distant buildings and scrutinizing the films with a magnifying glass. When several lenses are being compared in this way, it is essential that they be subjected to identical testing conditions. Even if you are careful, evaluating lens test results is often difficult. The usual 4x to 8x loupes are not really powerful enough for this purpose, and metering microscopes are expensive. When slides are projected, their magnification allows critical examination. Yet our visual memory is very short-lived and our eyes' ability to accommodate quite pronounced, making it difficult to compare several slides one after the other. Handmade enlargements produced by a professional laboratory are more useful but rather expensive.

Despite all these caveats, don't be discouraged from performing your own lens tests. I would simply advise that you take the utmost care in the production of test images and in the evaluation of the results.

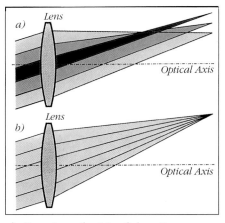

a) Coma is another type of aberration caused by the spherical curve of the lens elements. It produces a comet-shaped image patch from an object point.
b) The coma effect is reduced at a specific diaphragm opening.

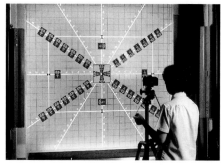

Arrange the target patterns for individual tests in a configuration similar to this industrial setup.

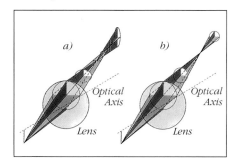

Astigmatism reproduces an off-axis object point as a cross created by two lines that are generated in opposite image planes.

Anyone particularly critical about their image quality should use well-corrected, high-quality lenses displaying impeccable definition and excellent contrast rendition. After all, sharp, brilliant pictures are never coincidental.

Interchangeable Lenses

The beauty of the interchangeable lens system lies in the limitless possibilities it affords us in being able to change an image's impact, composition, and perspective.

Many photographers think of interchangeable lenses in very simple terms: If you can't move far enough from a subject, use a wide-angle; if you're unable to get close enough, switch to a telephoto. This approach is a good start, but too limited. It ignores the most important purpose of choosing a focal length, which is to achieve just the composition that you want.

It has often been observed that photojournalist Henri Cartier-Bresson made photographic history using only a standard lens to take most of his pictures. Nearly all his famous images were made with a rangefinder Leica and a 50mm standard lens; only occasionally did he employ a 90mm or 35mm focal length. Yet every element in his pictures is superbly positioned, and perfectly harmonized with its surroundings.

Most of us, however, require interchangeable lenses to fulfill our photographic vision. A telephoto lens is helpful to record an object, animal, person or group from a discreet distance. On the other hand, the use of a moderate wide-angle lens allows a subject to be shown in his or her surroundings.

Focal Length and Perspective

In 35mm photography, the widest range of focal lengths is offered for SLR cameras. One way to compare focal lengths is to take a series of pictures from the same position

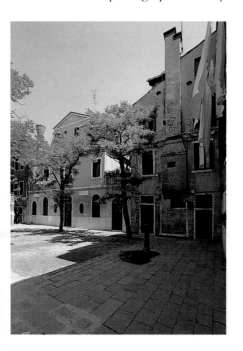

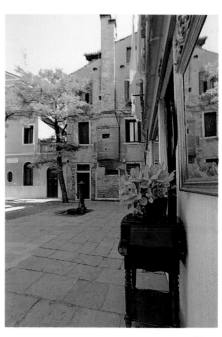

Both pictures were made with the same focal length lens, but from slightly different positions. When searching for the best potential photograph, one should not be afraid to move around the subject.

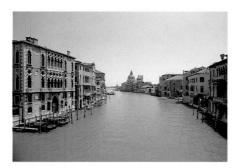

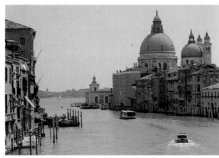

Both pictures to the left were taken from the same position, however one was taken with a wide-angle (above) and the other, a telephoto (below). The different effects in the two pictures are due to each lens' angle of coverage.

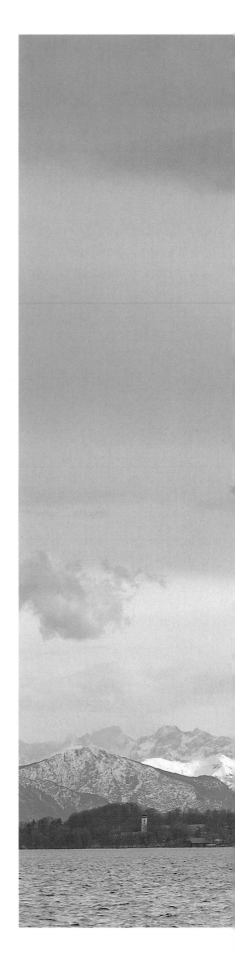

with different lenses, from ultra wide-angle to long telephoto. The subject gradually grows from a distant view to an extreme close-up. This comparison demonstrates that, despite common misconceptions, focal length does not influence perspective. If you made an enlargement from a tiny portion of a wide-angle shot, its perspective would exactly match that of a telephoto image. (Grain and sharpness would suffer in the large blowup, of course.) In the 35mm format, perspective is solely determined by the camera's position in relation to the subject.

Another, more instructive focal-length comparison, involves the photographer changing position to keep the main subject constant in size each time the focal length is switched. The resulting comparison photos display the differing perspectives resulting from changes in camera-to-subject distance, particularly in the rendition of the background.

Lenses and Vision

Photographic lenses "see" differently than the human eye. Our vision is three-dimensional, with a sense of depth that is actually created in the brain. A lens, on the other hand, sees a two-dimensional image only. The impression of depth has to be created by the lighting effects, composition, depth of field, and perhaps by showing the relationship between the foreground and the background.

Unlike a lens, our eyes are constantly correcting the images we see, for example by "straightening" converging lines. Our visual perception works selectively, so that we don't necessarily "see" everything in our field of view. A lens, however, registers everything within its picture angle. While composing a picture, you may not notice the annoying telephone wires in a rural scene, but they are sure to turn up in the resulting photograph.

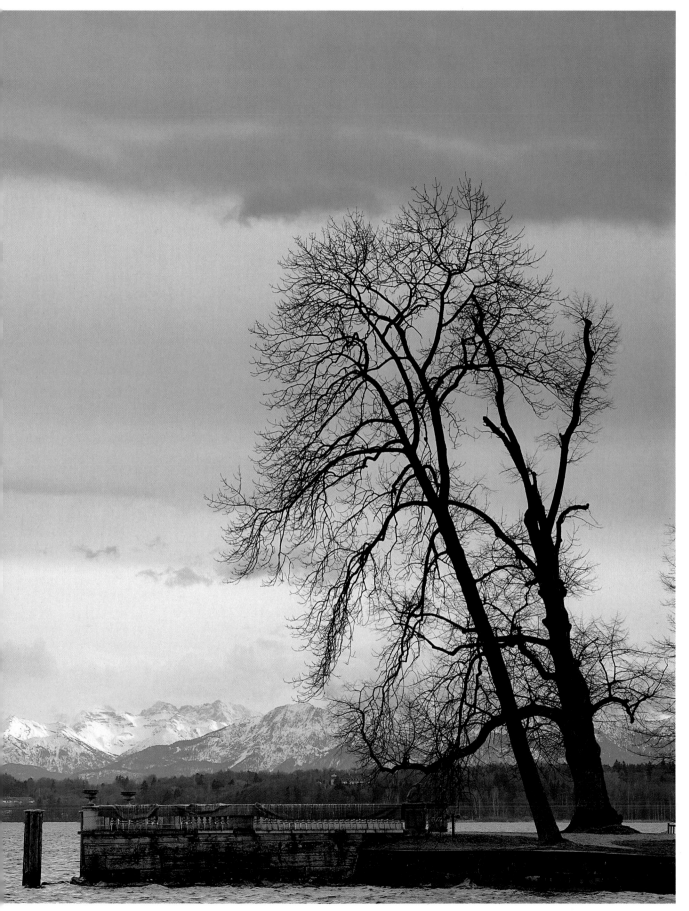

Even a small step sideways can dramatically change the scene in the viewfinder and thus the picture's impression. These two shots were made with a focal length of 15mm from positions approximately three feet apart.

Composition and Focal Length

Interchangeable lenses are decisive tools in producing expressive images. To begin with, you need to become familiar with how each lens "sees," and its role in composing a picture. As the accompanying photographs show, choice of focal length offers the freedom to determine perspective by changing the camera's position.

Longer focal lengths, with narrower picture angles, tend to isolate the subject from its surroundings and force the viewer to concentrate on the selected object. Such isolation can also emphasize a subject's details. On the other hand, an object that seems isolated to the human eye can be visually "connected" to its surroundings by employing a short focal length lens with a large angle of view. A standard lens, used from a medium distance, will usually make an object seem as natural and similar to human vision as possible.

Photos made with wide-angle lenses tend to show a large section of background in which the sense of depth is accentuated. In many situations, wide-angle photos have a dynamic appearance. The main subject in the foreground is emphasized, and its proportions may be distorted. Meanwhile, objects in the background rapidly diminish in size.

With longer focal lengths, the visible area behind the main subject becomes narrower, and the appearance of depth is less pronounced. Changing the camera position and the focal length results in varying impressions of depth and space in a picture. You can make the foreground appear to "move" closer to the background, even if both are absolutely stationary. Space seems to compress and, with very long focal lengths, the horizon may disappear from the frame. A sense of balance is created, as objects in the background appear larger, and the foreground subject becomes less dominant.

Knowing Your Lenses

Freedom to choose the ideal picture-taking position is only possible if several focal-length lenses are available. This does not mean that the indiscriminate use of interchangeable fixed focal length lenses or zooms can guarantee interesting photographs. On the contrary, dealing with too many lenses may lessen the photographer's concentration on the subject, and on the intended idea behind the picture. Carrying too much equipment may also prove tiring, which will not enhance your mood or motivation. If you do carry more than one camera, the nuisance of changing lenses can be avoided by fitting one camera body with a wide-angle lens and another with a telephoto zoom. Just be sure not to give up picture-taking flexibility in exchange for this convenience.

In any case, it makes good sense to experiment with different focal lengths until you are thoroughly familiar with every lens you own. Try a variety of shooting positions and distances, while frequently previewing depth of field to make sure that important items are in focus. Also, look for vertically oriented subjects, and become familiar with holding and using your camera in the vertical position.

Taking just one lens on a short photographic excursion can be a great help in getting to know its point of view. Try changing your distance to the subject, as well as the camera's position (by tilting the

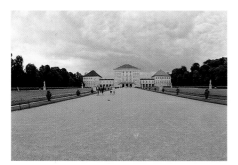

16mm Fisheye focal length

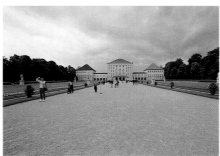

15mm focal length

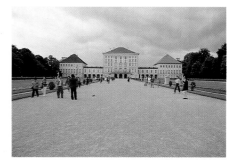

21mm focal length

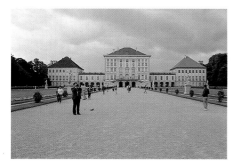

28mm focal length

50mm focal length

100mm focal length

180mm focal length

280mm focal length

500mm focal length

camera, crouching down, shooting from an elevated position, etc.). By concentrating on a single focal length, you learn how the lens affects composition and the sense of perspective, and how and when to use it so it is most effective.

It's also interesting to shoot the same subject with various focal lengths. When switching to a telephoto, try picking out details within a large subject, such as a landscape or city panorama, to create different pictorial effects. This exercise will illustrate the relationship between focal length, camera position, perspective, and reproduction ratio. Work on it awhile, and you may discover a favorite focal length, which should yield some great photographs.

A comparison of focal length:
Every one of these pictures was taken from the same position but with different focal lengths. Changing only the focal length has no greater effect on perspective than merely enlarging one area of a wide-angle shot.

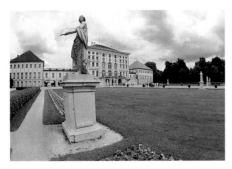

16mm Fisheye focal length

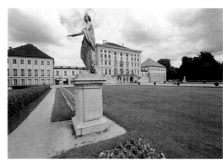

15mm focal length

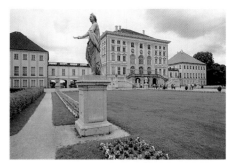

21mm focal length

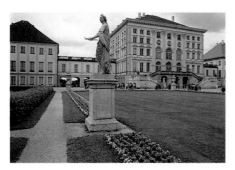

28mm focal length

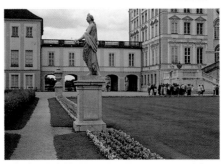

50mm focal length

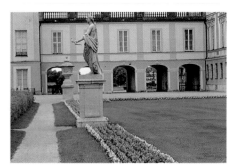

100mm focal length

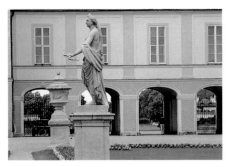

180mm focal length

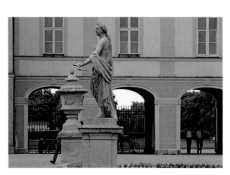

280mm focal length

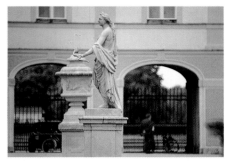

500mm focal length

A comparison of perspective:
Perspective is affected by moving the camera
position to keep the main subject (the statue,
in these photos) identical in size while using
lenses of different focal lengths. Changing the
focal length and camera position can com-
press or enhance the illusion of space in a
photograph and change the subject-to-back-
ground relationship dramatically.

Choosing the Right Lenses

Manufacturers offer hundreds of lenses for the 35mm format, making it difficult for the SLR photographer to select the right ones for his or her needs. To simplify the process, consider the basic questions that follow.

— Is your camera autofocus or manual focus?
— Are fixed focal length lenses better than zooms?
— How important is lens speed?
— Which focal lengths make sense for your type of photography?
— Are there special lenses to expand your picture-taking horizons?

Naturally, there is no universal answer to these questions, because each photographer's situation and demands are different. However, pondering the basic issues, in relation to your own favorite subjects and style of shooting, will help narrow your potential choices.

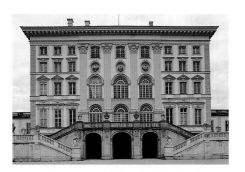

This is how we expect the building to look.

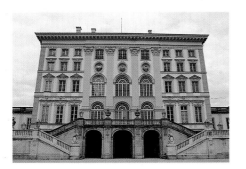

This is how a lens reproduces the subject.

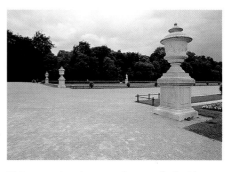

This expansive view was photographed with a focal length of 21mm.

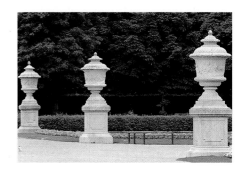

The space appears compressed with a 280mm focal length.

Both photos (above) depict the same scene. The different relationships of space and size result from the photographer varying the camera's position and lens focal length.

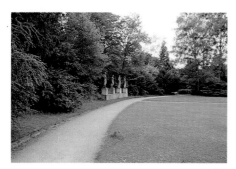

21mm focal length, full frame

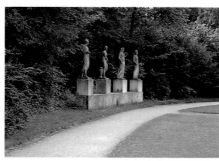

100mm focal length, full frame

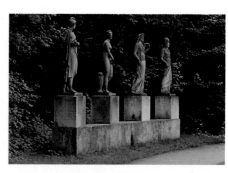

180mm focal length, full frame

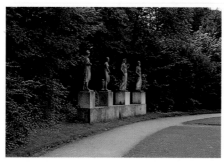

21mm focal length, enlarged

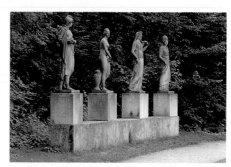

100mm focal length, enlarged

This series of photos shows quite plainly that perspective is not determined by the focal length, but by the camera's position. The photos are all made without moving the camera. The enlarged areas of the photos made with 21mm and 100mm focal lengths are identical to the photo made with a 180mm focal length. The result—every photo displays the same perspective in spite of the different focal lengths employed.

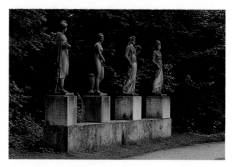

21mm focal length, enlarged

Fixed Focal Length or Zoom Lenses?

From year to year, zoom lenses continue to gain in popularity. Virtually every AF camera system, and most manual-focus models, include several zooms in their lens lineups. The most obvious advantage of zooms is their added flexibility. While a prime (or fixed focal length) lens has only a single focal length, a zoom model covers a range of focal lengths (such as 35-70mm, 28-105mm, etc.), replacing several lenses at once.

This allows a stepless choice of focal lengths, so you need only zoom the lens to try framing the subject differently. Creating the final full-frame composition at the moment of exposure is particularly valuable with transparency film, which is seldom cropped before projection. But remember, format-filling photos cannot take the place

of a serious search for the optimum position necessary for perfect perspective and composition. Even with zooms, sometimes you've got to move!

As was mentioned in the last chapter, when visualizing a picture, you should imagine how it would look if taken with various focal length lenses. In a well-chosen range of lenses, each focal length relates logically to the next, making it simpler to visualize the effect even

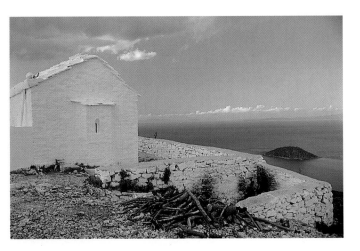

The three photos at left and below (in the center of the page) are all of a chapel on Samos. However, they were made with varying focal lengths and from different positions.

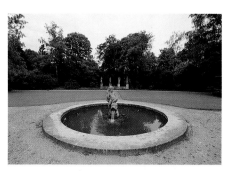

15mm focal length, from a short distance

28mm focal length

100mm focal length

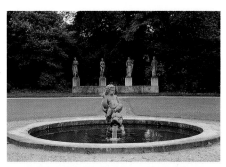

100mm focal length, from a moderate distance

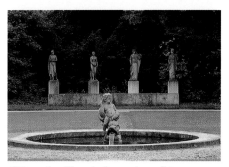

180mm focal length, from a long distance

These photos show the effect of perspective on circular and rectangular objects. Note how the shape of the circular fountain differs with changes in camera-to-subject distance. In the background, the statues' base changes in size but not in shape.

before you actually change lenses. With a zoom, of course, much of this visualization can be achieved at the touch of a control ring.

The down side of zoom lenses is that they can make you lazy. Many photographers using zoom lenses forget to "dance" around their subjects in search of the best perspective. Also, in spite of the freedom to choose the optimum focal length from the stepless range of a zoom lens, too many photographers

regularly use the minimum and maximum focal lengths only. If you're shooting with a 28-105mm zoom, for example, don't neglect the intermediate settings, which include the classic 35mm, 50mm, and 85mm focal lengths.

It is not by chance that zoom lenses are so popular, and their practical advantages should not be underrated. Zooms cover a wide range of focal lengths, so there is less need to change lenses and

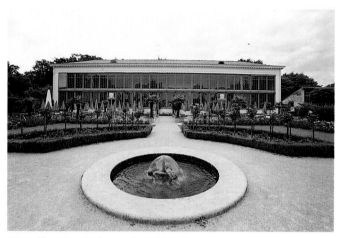

15mm focal length, from a short distance

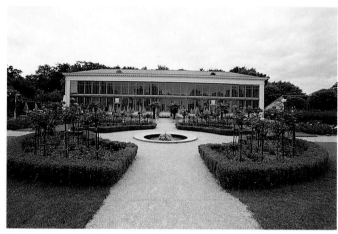

15mm focal length, from a long distance

The photos above were both made with an extreme wide-angle lens, but from different distances. The rectangular shape of the building is not distorted in either case, while, due to the change in perspective caused by the change in shooting distance, the round fountain appears to have changed shape.

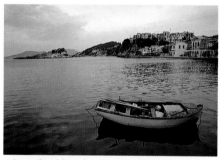

28mm focal length

200mm focal length

Wide-angle and telephoto shots taken from slightly different positions; the 7x difference between the two focal lengths is covered by a 28-200mm zoom lens.

fewer lenses to carry around. In addition, while one zoom lens may cost more than a prime lens, it is considerably cheaper to purchase than the several fixed focal length lenses it replaces.

Zoom lenses in the 28-80mm or 28-105mm range are well suited for landscape and travel photography, and serve as good general-purpose optics. Normal-to-telephoto zooms, such as 70-210mm or 60-300mm, are also useful for landscape and travel work, as well as portraits, sports, and animal shots taken from a moderate distance.

Some photographers carry only one wide-range zoom, such as a 28-200mm. This is certainly convenient, because you avoid the hassle of carrying and changing several lenses. Equally important, with no time wasted on changing lenses, you are always ready for unexpected photo opportunities. On the other hand, the wide range zoom is generally larger and heavier than a conventional short zoom, such as a 28-135mm. Even the new "ultra-compact" and "ultralight" models tend to weigh over a pound, considerably more than the typical normal or wide-angle lens.

Zoom lenses also allow the once-popular "creative zoom blur"

pictures caused by changing the focal length setting during the exposure. While it still can produce interesting photographs, this effect has become rather overdone.

Perhaps the biggest question still asked by countless photographers concerning zoom lenses is, "How does their image quality compare to that of fixed focal lengths?" A common answer from manufacturers and dealers is that present zoom lenses are designed to deliver optical quality comparable to that of prime lenses. But, as usual, reality is a bit more complicated, based on tests performed with actual lenses.

Advances in the development of new types of glass, aspherical lens elements, computer-supported lens designs, and lens construction have improved the image quality of zoom lenses considerably in the last few years. It is hardly surprising that modern zooms show substantially better image quality than earlier models. However, these same developments in technology have been applied to prime lenses as well.

It is only fair to compare equivalent models, that is middle-range zooms with middle-range fixed focal lengths, or high-power zooms with high-power fixed focal length

lenses. When these comparisons are made, you find that prime lenses still offer image quality superior to that of zooms. Generally, the difference is most noticeable at the zooms' maximum-focal-length settings. In the case of zoom lenses covering a large range of focal lengths, such as 28-200mm, the best image quality is often achieved at the widest setting.

At full aperture, zooms are generally inferior to fixed focal lengths, due to spherical aberration and the diaphragm's changing position. For average subjects at moderate settings such as $f/8$ or $f/11$, prime and zoom image quality tend to be roughly comparable, although a deterioration toward the edges of

zoom pictures is still visible. Very finely detailed subjects reveal a difference at the center of the image to the advantage of fixed focal lengths, even at optimum aperture settings.

Many zooms display a degree of spherical aberration, especially at close range and full aperture, giving a visible lack of definition toward the edges when flat objects are photographed. By stopping down to about $f/11$, you can virtually eliminate this loss of sharpness, but at the price of a longer exposure.

Zoom design, which requires a shifting position for the diaphragm, creates more pronounced distortion and vignetting than occurs in prime lenses. When shooting subjects with straight lines, most zooms

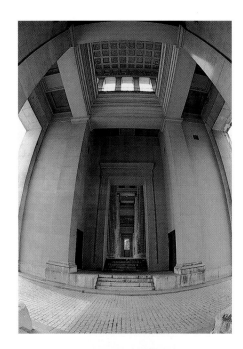

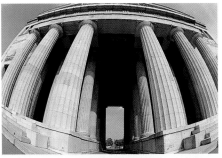

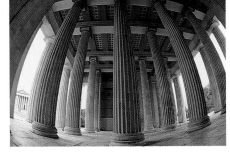

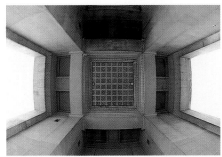

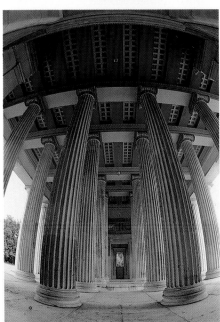

In order to "get acquainted" with a lens, try photographing a single subject from different positions. These shots of the Propylaen in Munich were made with a 16mm fisheye lens to show how a single lens can be very versatile.

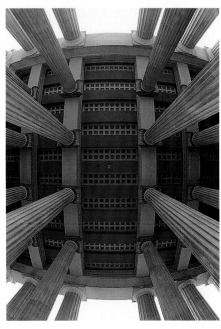

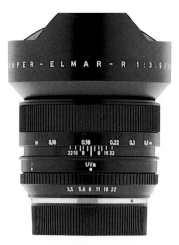

The Leica Super-Elmar-R 15mm f/3.5: an example of a focal length not yet covered by any zoom lens.

The Zeiss Tessar T 45mm f/2.8 for Contax cameras is the smallest interchangeable lens presently available for a 35mm SLR.*

display barrel distortion at their shortest focal length and pincushion distortion at longer settings. These distortions may prove unacceptable for some architectural photos.

Available-light photographers should note that zooms tend to be slower than comparable prime lenses. Depending on the focal length, most zoom lenses have a maximum aperture between $f/3.5$ and $f/5.6$. The design of many zooms includes numerous lens elements, causing a relatively large quantity of light to be absorbed. Although this is taken into account by the camera's through-the-lens metering system, exposures will require relatively slow shutter speeds in low light and therefore possibly a tripod or other camera support. It also limits the possibility of using a large aperture to throw the background completely out of focus.

The designation for zoom lenses often includes two *f*-numbers. In order to keep zoom lenses as small and lightweight as possible, the

maximum aperture is designed to vary with the change in focal length. The aperture is largest at the shortest focal length, then continually diminishes as the focal length is increased. The aperture variation is taken into account by the camera's TTL metering system.

In some zooms, the front lens element retracts into the barrel as the focal length is increased. This helps prevent flare by shading the front element from stray light. It can place limits on using filters or extending the lens to its maximum focal length though. Attaching filters that are larger than the diameter of the lens barrel will restrict the lens' zoom range. When a polarizing filter is used, rotating the filter becomes impossible if the front element has moved back into the barrel. (If the front element doesn't rotate, avoid this problem by adjusting the polarizer and then zooming the lens.) Also, the filter mount may cause vignetting when a wide-angle zoom lens is set to its shortest focal length.

Wide-angle to moderate-telephoto zooms often have rather limited close-focusing abilities. For example, a 28-200mm zoom may focus down to about 6-1/2 feet (2 meters). Although this may be acceptable at the telephoto end, it is certainly too long for a wide-angle, since it considerably restricts the possibility of emphasizing objects in the foreground against a vanishing horizon. A conventional 28mm lens focuses to about 1 foot (0.3 meters).

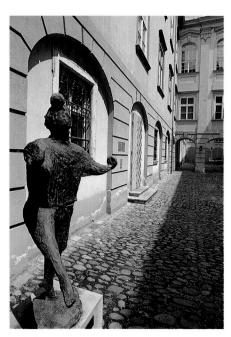

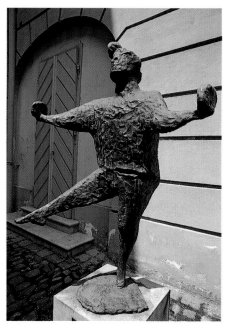

The two photos to the left illustrate again how important it is to move around the subject. Seeing the statue from different vantage points changes the picture's expression.

21mm focal length

50mm focal length

252mm focal length (180mm with a 1.4x tele-converter)

These three photos were taken with a wide-angle, a standard, and a telephoto lens. The 12x magnification difference between the two most extreme focal lengths cannot be covered without changing lenses, even when a zoom lens is used.

These comments should not be taken as an aspersion against zoom lenses. On the contrary, they represent an attempt to take a critical look at the "zoom mania" we have encountered from the manufacturers and dealers over the last few years. Each photographer has to decide what features are important to his or her type of work. Replacing several prime lenses with one zoom lens is appealing for any photographer wanting to travel light. Any slight loss of image quality may be irrelevant for a photographer using color negative film to make 8x10-inch prints. Before deciding upon any lens, zoom or prime, every photographer should look at the individual lens' advantages or disadvantages in view of his or her need for image quality, favorite subjects, and individual way of working.

Auto or Manual Focus Lenses?

The choice between autofocus (AF) and manual focus (MF) lenses is largely dependent on the camera being used with them. Most current cameras and lenses are autofocus models. That doesn't mean, however, that AF is always the right choice.

The most important aspects of focusing will be dealt with in a later chapter, "Focusing." At that point, the advantages and disadvantages of automatic focusing will be discussed in detail. One advantage of AF is certain: Autofocus technology enables photographers with less-than-perfect sight to produce sharper pictures than they could achieve by setting the distance manually. Beyond that, AF does not always guarantee sharp photos.

With moving subjects, AF may reduce focusing errors in some situations. To facilitate fast response, many autofocus lenses are built with plastic barrels, and sometimes with plastic lens elements as well. This allows faster response time because of less demand on the focusing motor—a great setup for action, but not necessarily the ideal for producing excellent image quality.

Even with an AF system, you can usually focus manually. But AF lenses often have only a thin and hard-to-grip focusing ring for manual operation. Few offer manual focusing that's as convenient as a strictly manual lens.

Manual focusing is well suited to photographers who keep the camera mounted on a tripod and set exposures manually, use extreme wide-angle lenses in unconventional positions, do macro work, or want strict control over a narrow area of focus. But those who prefer a carefree and spontaneous approach will immediately appreciate AF lenses.

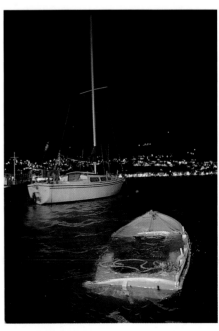

Use manual focus for off-center subjects and in low-light situations.

The AF Nikkor 85mm f/1.8 lens

Choosing Equipment

Photography is becoming as specialized as every other aspect of our lives. In fact, every assignment calls for a degree of specialization if professional standards are to be met. Amateurs have less need to restrict themselves, although they may want to concentrate on just a few subjects at the beginning. Once you've identified a favorite subject, it's time to explore the technical requirements for the most suitable equipment.

Below are suggestions for 35mm-format equipment best suited for various subjects. While based on extensive experience, the lists are only suggestions, which serve as a good starting point.

The focal lengths given are fairly standard, but may vary slightly between manufacturers.

The Zeiss Distagon T 21mm f/2.8 lens for the Contax bayonet mount*

Architectural Photography
Basic outfit: One camera body with a 35mm shift lens and 28-70/80mm zoom.

Standard outfit: One camera body with 24mm, 28mm or 35mm shift, and 135mm lenses.

Expanded outfit: Two camera bodies with 20mm, 28mm shift, 50mm, 100mm, and 180mm or 200mm lenses.

Professional outfit: Three bodies with 15mm, 16mm fisheye, 20mm, 28mm shift, 50mm, 100mm macro, 180mm or 200mm, and 300mm. (Both telephoto lenses should be apochromatic.)

Landscape and Nature Photography
Basic outfit: One camera body with a 28-70mm or 28-80mm zoom.

Standard outfit: One camera body with 28mm, 50mm, and 85mm prime lenses or a 28-70mm zoom, plus a 70-210mm zoom.

Expanded outfit: Two camera bodies with 20mm, 28mm, 50mm, 100mm macro, and 180mm or 200mm lenses.

Professional outfit: Three camera bodies with 15mm, 20mm, 28mm, 50mm, and 100mm macro lenses, a 180mm or 200mm telephoto (preferably apochromatic), and a 2x teleconverter (preferably apochromatic).

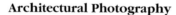

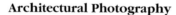

A telephoto zoom: The Minolta Zoom xi 100-300mm f/4.5-5.6 lens

Portrait Photography

Basic outfit: One camera body with a 35-135mm zoom.

Standard outfit: One camera body with 50mm, 90mm, and 135mm prime lenses, or a 35-135mm zoom.

Expanded outfit: Two camera bodies with 35mm, 50mm, and 100mm prime lenses, or a 35-135mm zoom, plus a 180mm or 200mm telephoto.

Professional outfit: Three camera bodies with 24mm, 35mm, 50mm, 100mm, 135mm, and 180mm or 200mm lenses.

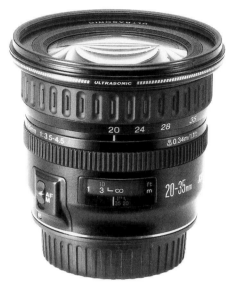

The Canon EF 20-35mm f/3.5-4.5 USM lens

Travel Photography

Basic outfit: One camera body with a 28-70mm or 70-210mm zoom.

Standard outfit: Two camera bodies with 28mm and 50mm lenses, plus a 70-210mm or 60-300mm zoom.

Expanded outfit: Two camera bodies with 21mm, 28mm, 50mm, and 100mm macro lenses, a 180mm or 200mm telephoto, and a 2x teleconverter.

Professional outfit: Three camera bodies with 15mm, 21mm, 28mm shift, 50mm, and 100mm macro lenses, 180mm or 200mm apochromatic telephoto, and a 2x apochromatic teleconverter.

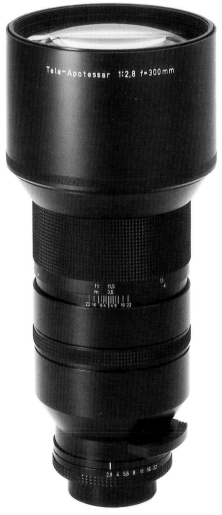

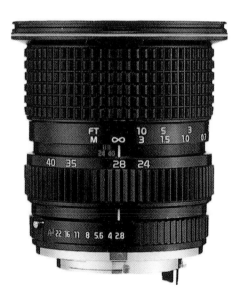

The Tokina AT-X 240 24-40mm f/2.8 lens

The Zeiss Tele-Apotessar 300mm f/2.8 lens

The Canon EF 75-300mm f/4-5.6 USM lens

An example of still-life photography. For this picture, a macro lens was employed.

Still-Life Photography

Basic outfit: One camera body with a 28-70mm or 28-80mm zoom.

Standard outfit: One camera body with 24mm, 50mm or 60mm macro, and 85/100mm lenses.

Expanded outfit: Two camera bodies with 20mm, 35mm, 60mm macro, 85mm, and 135mm lenses.

Professional outfit: Three camera bodies with 20mm, 35mm, 60mm macro, 100mm macro, and 135mm lenses, plus a 180mm or 200mm telephoto.

Wildlife Photography

Basic outfit: One camera body with a 70-210mm zoom.

Standard outfit: Two camera bodies with a 60-300mm zoom and a 500mm mirror lens.

Expanded outfit: Two camera bodies with 180mm or 200mm, 300mm, and 500mm or 600mm telephotos, plus a 2x teleconverter.

Professional outfit: Three camera bodies with 100mm macro, 180mm or 200mm, 300mm, and apochromatic 400mm, plus 500mm or 600mm and 800mm telephotos, 1.4x and 2x teleconverters.

Focal Length

Focal length is the most important attribute of any lens. Therefore, each of the following sections deals with a specific focal-length group, discussing the common characteristics of its members. Where necessary, we also mention the points of distinction between individual lenses within a group.

In general, comments concerning a given focal length are valid for all lenses of its type. There is no inherent difference in perspective or composition between photographs taken with a prime or a zoom lens, with manual focusing or with an AF system. The only distinctions between individual lenses of the same focal length are of speed and image quality—definition, contrast, distortion, and vignetting, all of which have been discussed thoroughly in previous chapters.

Ultra Wide-Angle Lenses (13mm-21mm)

The lenses in this range have huge angles of coverage, ranging from 118° (for 13mm) to 92° (for 21mm; each measured diagonally). Although they fall in the same range of focal lengths, the ultra wide-angle lenses should not be confused with fisheye lenses (discussed with other special-purpose lenses.)

Originally used only when a photographer literally had his or her back to the wall, ultra-wides have become popular for aesthetic reasons as well. Extreme wide-angle lenses produce dramatic impressions of space. The foreground tends to dominate the picture, especially if the lens is close to the main subject, while the background appears to drift into the distance. At the close-focus settings of 6-8 inches (16-20 cm), even small objects can fill the frame.

Ultra wide-angle lenses display extensive depth of field, even at maximum aperture. Stopping down extends it even further, allowing everything from foreground to background to be pictured sharply. The impression of space is enhanced by the enormous depth of field and by the strong rendition of perspective, giving the picture a three-dimensional appearance.

As you quickly discover, such vast coverage creates visual effects very different from those of more moderate lenses. This allows for new creative possibilities, but also makes ultra wide-angle lenses difficult to use (not just for beginners). In photos with dominant foregrounds, strongly tapering backgrounds, and wide expansive horizons, composition becomes difficult. To begin with, the main subject must be carefully positioned, often in ways not dictated by the classic "rule of thirds" approach. And as the picture angle

The extreme angle of view of a wide-angle lens (92° in this case) will often encompass a contrast range greater than the film can reproduce. Here a graduated neutral-density filter prevents the bright sky from appearing washed out.

The strong emphasis of vanishing lines...

...is one of the characteristic features of ultra wide-angle lenses.

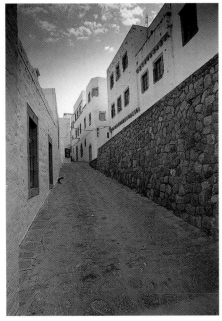

grows, a wealth of details may be revealed, including some annoying ones. Often, this will only be noticed too late, when the image is projected or enlarged. So an ultrawide photo should be composed very consciously and the complete viewfinder image thoroughly examined.

Simply trying to align the camera properly may be difficult as well. Ultra wide-angle lenses have always been useful for shooting in small rooms. Be sure not to tilt the camera, however, at least not accidentally. Straight-on flash is not likely to provide even illumination across the large picture angle, so bouncing light off the ceiling may be a better solution.

Photojournalists use the ultra-wide "look" to draw the viewer right into the scene. At moderate distances, ultra wides can even be used for quick candid shots, because the depth of field will cover minor focusing errors, and there is little danger of camera shake.

Ultra wide-angle lenses are also well suited for architectural photography. Their large angle of coverage can allow multistoried buildings to be depicted completely, without converging lines, even from relatively short distances. To ensure that the film plane is parallel with the subject, it's best to use a focusing screen with a grid of etched vertical and horizontal lines, or a bubble level that can be attached to the camera's accessory shoe. Grid-type focusing screens are also a help for focusing, because they allow the distance to be set at any desired point of the negative area.

Architectural pictures taken from a comparatively low position may include a lot of foreground, perhaps the surface of a street or a lawn. This is not necessarily a

drawback, since it can often be made part of the composition. Should the foreground be totally dull, however, you can always crop it out when making an enlargement or duplicate slide.

Even converging lines are not a problem: Use them to create a dynamic sense of composition. For example, a "worm's-eye" view can emphasize perspective and exaggerate (or perhaps even reverse) the size ratio in an architectural image. More generally, experimenting with unconventional points of view can intensify the picture's impact. Just do it with careful consideration of the image's original idea, because a haphazardly chosen position tends to be more bizarre than interesting.

Another consideration is that so wide a field often contains greatly varying levels of brightness and contrast, creating a challenge for the camera's metering system. Careful light metering is particularly important in landscape shots made with ultra wide-angle lenses. Due to their extreme angle of coverage, the sky often occupies large parts of the negative area. The resulting strong contrast between different sections of the image can mislead not only a center-weighted, but even a multi-field meter, leading to an underexposed foreground. Depending on the contrast and the amount of sky included, a correction factor from +1 to +2 stops may prove necessary.

For cameras with center-weighted or selective metering systems, great care should be taken to avoid including too much of the sky within the metering area. This is especially true if the horizon is in the lower part of the image. You may want to make a separate measurement of a gray card then lock in the resulting reading. Even better

are separate spot readings of high-light and shadow areas, adjusted to bring all important subjects within the film's brightness range.

Vignetting and distortion are two of the ultra wide's less-pleasant properties. Natural vignetting, defined by the rules of optical rendition, causes light falloff toward the image edges. The greater the picture angle, the greater the darkening. Artificial vignetting is the result of light being cut off by the inner edges of the lens barrel and is usually more annoying than the natural variety. Fortunately, advanced design methods have minimized artificial vignetting in today's better lenses. Even a top-notch lens may still produce noticeable vignetting, however, with evenly lighted subjects. The effect is most pronounced with the lens diaphragm wide open; closing down by two stops usually reduces or even eliminates vignetting.

Distortion is another aberration that increases with the picture angle, causing straight lines to be depicted as curves. In high-end ultra wide-angle lenses, distortion is usually well corrected, allowing the photographer to usually ignore it.

Some photographers confuse distortion with the perspective effects common to ultra-wide pictures. This perspective "distortion" is nothing more than an enlarged reproduction of the foreground in comparison to the background. The effect is entirely natural, the result of light rays having to travel a longer distance to the edges of the image than to its center. Distortion of perspective becomes more obvious with ultra wide-angle lenses simply because they tend to be used at short focusing distances. As the distance diminishes, and the field of coverage grows, the light rays at the edges

of the frame enter the lens at an ever-greater angle.

Ultra-wide perspective effects are not usually disturbing, except in portraits and certain areas of industrial photography. The result may be intensified if you tilt the camera, so be sure to keep the film plane parallel to the subject for a more natural impression.

13mm, 14mm, and 15mm Lenses

These lenses cover extraordinarily wide diagonal picture angles of 118°, 114°, and 110°, respectively, and include absolutely huge expanses of picture area. Prime lenses are available in both AF and MF versions, but these focal lengths are not covered by any zooms.

Generally, 13-15mm ultra wides have a minimum focusing distances of around 12 inches (30 cm). To maintain image quality at such short distances, the lens should have a sophisticated floating-element design. Combine close-focusing with a large angle of coverage, and you can create an overwhelming sense of perspective, even with small subjects such as tabletop models. A clod of dirt may be turned into a mountain, a puddle into a lake, or a pebble into a boulder.

Landscape and architectural photography are probably the areas best suited to the breathtaking perspective attainable with ultra-wide lenses. The 13mm, 14mm, and 15mm focal lengths are also ideal for indoor shots in small rooms. To avoid converging lines (unless intentionally used as a matter of style), the camera should be fitted with a grid-type focusing screen or a bubble level.

Really effective protection against stray light is impossible in this range of focal lengths, due to their extreme angles of coverage. A lens shade would need to be the

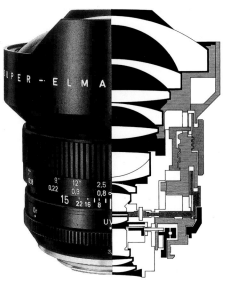

The Leica Super-Elmar-R 15mm f/3.5 lens with built-in filter turret

The Canon EF 14mm f/2.8 USM lens

Right: Getting in close with a wide-angle lens can make even comparatively small objects dominate the photograph.

Taken with a 19mm focal length from a short distance, small subjects in the foreground can assume impressive proportions.

size of an umbrella! The small scalloped shade integrated into the lens barrel protects the large, domed front lens element from mechanical damage more than it blocks backlight or sidelight. Additional shading with a hat or other object is somewhat risky, because the item could easily be included in the picture. These lenses are equipped with integrated revolving filters or a filter drawer. Threaded filters would not fit over the domed front elements, and they would cause vignetting in any case.

17mm, 18mm, and 19mm Lenses

These are the widest lenses used by most photographers, with diagonal picture coverage of a remarkable 103° (for 17mm), 100° (18mm), and 96° (19mm). Fascinating effects can be achieved with the exaggerated perspective characteristic of these focal lengths, including monumental foregrounds and dwindling backgrounds. Their extensive depth of field can also bring the viewer right into the action of a scene.

Typical close-focusing distances range from 10-12 inches (25-30 cm), for reproduction ratios up to 1:10 or 1:11. Like the 13-15mm lenses, the 17-19mm group is fine for model photography and general indoor work. Other excellent applications include landscape, journalistic, industrial, and architectural photography.

As mentioned earlier, vignetting can be a problem with ultra wides, especially at the maximum aperture. While "artificial" vignetting can be reduced almost completely by stopping the lens down, the uncorrectable "natural" shading may remain visible in evenly lighted areas. Depending on the quality of the lens, distortion may also be apparent to a greater or lesser extent. As a result, subjects with straight lines, such as buildings, may become somewhat curved toward the edges.

20mm and 21mm Lenses

Although the most "moderate" of the ultra wides, the 20mm and 21mm focal lengths still offer

expansive coverage angles of 94° and 92°, respectively. Lenses in this group are well suited for architectural, industrial, landscape, and model photography; they are also used for journalism, candids, and indoor shots. In the case of fashion and other advertising photos, the exaggeration of perspective can lead to strikingly effective images.

These lenses are mostly quite compact and lightweight, making them fine traveling companions. They are a bit easier to use than the shortest focal lengths, yet still allow the creation of dramatic perspective effects with monumental foregrounds, "vanishing" backgrounds, and a broad horizon. In addition to many prime lenses, there are a few zooms in this focal length range, including the Canon EF 20-35mm *f*/2.8L and *f*/3.5-4.5, and the Nikkor 20-35mm *f*/2.8D.

Wide-Angle Lenses (24mm-40mm)

The moderate wide-angle range, from 24mm to 28mm, represents a bridge between the ultra wides and the standard lenses. In fact, the focal lengths of 24mm and 25mm are more closely related to the ultra wide-angle lenses, while the 40mm focal length can almost be included with the standard lenses. This intermediate position contributes to the broad popularity of these moderate wide-angles.

Their relatively large picture angles range from 84° for the 24mm to 56° for the 40mm, and give your pictures wide-angle coverage without unduly emphasizing perspective. If the camera is aligned carefully, images have a well-balanced, natural look, even though their angle of coverage is greater than that of concentrated

human vision. Tilt the camera, however, or shoot from a low angle, and perspective will be depicted in an exaggerated form.

24mm to 28mm Lenses
Expansive depth of field and relatively fast apertures render the 24mm-28mm lenses ideal for on-the-spot journalism. Landscapes, city panoramas, candids, and group portraits are other strong applications. The 24mm and 25mm models, in particular, are favorites for indoor assignments in available light. They allow the viewer to be brought right into the scene, by including the main subject, as well as the immediate surroundings.

The 28mm lens is regarded by many photographers as a universal wide-angle focal length. With a picture angle of 74°-76° (depending on the design), it offers a pleasant combination of broad coverage and easy handling. Tilting or shooting from odd angles will have less obvious consequences than with ultra wide-angle lenses. In addition, 28mm lenses can be used with most built-in or add-on flash units, which will illuminate the entire picture area. (Add a diffuser and usually the 24mm's picture angle will be covered.)

35mm to 40mm Lenses
For decades, 35mm lenses were the most popular wide-angles, mostly because they were the only ones sufficiently corrected for high optical quality. More recently, improvements in lens technology have made it possible to design well-corrected wide-angle lenses with increasing angles of coverage. Beyond the technical realm, the improvements in the ultra wide-angle lenses have also changed our way of seeing. Now photos taken with 35mm lenses are no longer

With a wide-angle lens, changing the camera position will have a much more noticeable effect on the foreground than the background.

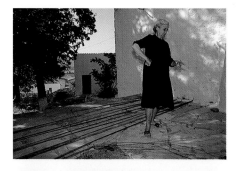
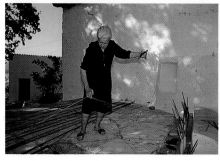

The 28mm focal length is excellent for depicting people in their surroundings. It is usually the widest coverage provided by a built-in flash unit. Fill-flash was used for these two photos.

Taken with a 35mm lens, this image benefits from the wide-angle lens' depth of field while picturing the young woman quite naturally.

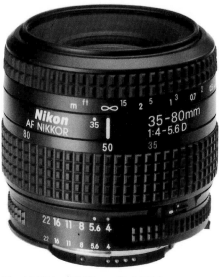

For photographing landscapes, a 35mm lens produces an expansive feeling without creating obvious distortion.

perceived as wide-angle images, but simply seem normal.

Logically, this alteration has diminished the attractiveness of the 35mm as a wide-angle lens and increased its use as a standard lens. With its picture angle of 64°-62° (depending on the design), the 35mm lens covers a considerably larger area than a 50mm normal (or standard) lens, yet tends to provide a normal rendition of perspective. The depth of field is also greater than a standard lens, and the shorter, lighter lens reduces the risk of camera shake. These characteristics lend themselves to candid photography, journalistic work, realistic landscape photos, group shots, and individual portraits that include the subject's environment. In addition, still lifes of larger objects and nearby architectural details are the 35mm focal length's natural domain.

A range of maximum apertures from $f/1.4$ to $f/2.8$ are available on prime 35mm lenses, with most zooms being somewhat slower. The fastest prime lenses, from $f/1.4$ to $f/2$, are excellent for available-light photography. Photographers who can live with less speed will find the $f/2.8$ versions to be compact and lightweight, making them fine "normal" lenses, especially for travel.

The 40mm focal length has become quite rare among prime lenses, although it is included in wide-angle zooms such as the Tokina AT-X 24-40mm $f/2.8$ and innumerable wide-angle-to-telephoto models. Its focal length is very close to the 35mm format's diagonal (43.3 mm), creating in effect a slightly wide standard lens. Functionally, a 40mm lens has applications similar to those of a 35mm, with a moderately narrower picture angle.

Standard Lenses (50mm-60mm)

Although the 35mm format has a diagonal of 43.3 mm, lenses with a focal length of 50mm are considered standard or "normal" lenses. The first lens produced in quantity for the 35mm format was the Leitz Anastigmat 50mm $f/3.5$. Other manufacturers followed suit and 50mm became well established as the standard lens for the 35mm format.

As it happens, the 45° angle of view of a 50mm lens is nearly identical to the angle of sight our eyes can see sharply in their resting position (the concentrated area of human vision). Therefore, we tend to use the lens in ways that create natural-looking images. (As explained earlier, perspective is actually a product of camera-to-subject distance, not focal length.) Human vision, however, is quite different from that of a lens. You move your eyes and/or your head to "scan" the surroundings, as the scene is integrated in the visual areas of the brain. So a larger angle is covered, making the standard lens' picture angle seem somewhat

The AF Nikkor 35-80mm f/4-5.6 D lens

cramped. This fact, and the increased availability of wide-angle lenses, has contributed to a widespread opinion that compositions taken with a normal lens are bland and boring. The photographs of numerous notable photographers have proven this preconception wrong time and again.

Along with 50mm standard lenses, some manufacturers offer 55mm (43° angle of view) or 60mm (39° angle) variants, usually with macro-focusing capabilities. These tend to be quite sharp throughout the focusing range and are often used as standard lenses. The slightly narrower picture angles of 55mm and 60mm lenses may come in handy for shots of details.

Lenses with focal lengths of 50mm, 55mm, or 60mm can be used in almost any area: journalism, candids, travel, still lifes of large objects, architectural details, posed portraits, and groups of people. As a rule, normal lenses are compact, lightweight, and modestly priced. Fast standard lenses (around *f*/1.4) are perfect for available-light photography, at night or indoors.

Numerous zoom lenses are available in this focal-length range. Instead of buying a prime lens, many photo dealers offer a camera body packaged with a standard zoom, such as a 35-70mm, 28-70mm, 28-80mm, 28-85mm, or 28-105mm. If you don't purchase a kit, start with a 50mm lens and branch out later when you find out what you want to add.

Moderate Telephoto Lenses (70mm-180mm)

The focal lengths between 70mm and 135mm are the most popular in the telephoto range. Prime lenses or zooms of this type are easy to handle and very versatile. In fact, moderate telephotos are comparatively simple to design and often display excellent overall image quality. Their relatively narrow picture angle simplifies composition, by concentrating on the main subject and eliminating extraneous surroundings. Compared with wide-angle and normal lenses, less subject matter is included in the scene (assuming the same camera-to-subject distance), at a larger reproduction ratio. Their shallow depth of field at wide openings can set the sharply rendered main subject against a soft background.

Another advantage of moderate telephotos is their tendency to gently compress the space within the object area. The effect is not as distinct as in longer focal lengths and thus still appears natural to the viewer. Also contributing to the

It is a common misconception that compositions taken with a standard lens are ordinary and dull.

Moderate telephoto lenses (80-100mm) are often called portrait lenses. More intimate photographs are possible without having the camera uncomfortably close to the subject.

The Tamron AF 28-200mm f/3.8-5.6 is an extremely compact zoom lens that covers a wide range of focal lengths. Its shortest focusing distance of 7 feet (2.1 m) is a bit too long for the wide-angle and normal range. The optional close-up lens A9F enables focusing down to 3.2 feet (1 m).

The four photos above were taken with a 100mm macro lens and underscore the strengths that a macro-lens with this focal length can have. All of the photos are hand-held shots taken in ambient light.

natural impression is the fact that these lenses produce very little distortion, creating a very pleasing perspective for portrait subjects. Additionally, format-filling shots are possible from moderate distances, allowing the photographer to work at a comfortable distance from the subject. These properties have made 80-100mm optics so popular for photos of people that they are often called portrait lenses.

These characteristics make moderate telephotos ideal for still lifes and for details of landscapes or buildings. Because they tend to be relatively compact and fast, hand-held shooting is easy. Appropriate uses include journalism, travel, fashion, and candids taken from a discreet distance.

It is possible to subdivide the moderate telephoto range into two parts. On the less-powerful end, fixed focal lengths include: 70mm (picture angle 34°), 75mm (31°), 80mm (30°), 85mm (28.5°), and 90mm (27°). The particular offerings vary with each manufacturer. The most advanced lenses in this subgroup have extremely fast maximum apertures of $f/1.2$ or $f/1.4$. The resulting bright and clear viewfinder images and the shallow depth of field facilitate accurate manual focusing even in adverse lighting conditions. The extraordinarily fast lenses in this group are fitting instruments for portraits and theater shots, especially where an existing-light atmosphere is to be captured.

The longer variants of the moderate-telephoto group include: 100mm (picture angle of 24° or 25°, depending on the design), 105mm (23.3°), and 135mm (18°). Lenses of 100mm and 105mm often have macro-focusing capabilities, up to about one-half life-size on film. Again, these optics are relatively

easy to design, with symmetrically arranged elements, so they give excellent results at all shooting distances.

Focal lengths of 100-105mm are well suited for portraits, journalism, available-light photography, and still lifes (including small objects). They can also be used for landscapes, revealing fine resolution of details and for architectural photos (either of details or of entire buildings taken from greater distances).

The 135mm focal length, with its picture angle of 18°, is used from distances that create a more pronounced telephoto effect (compression of space) than the other lenses in this group. Hand-held shots should be made at shutter speeds of 1/250 second, or better still 1/500 second, to avoid camera shake. The versatile 135mm can be used for portraits, architectural details, candids from greater distances, and still lifes. It is even long enough for photos of zoo animals. Relatively compact and lightweight, this is an ideal lens for travel photography.

The span between 70mm and 180mm is covered by numerous AF and MF zoom lenses, including 35-135mm, 28-200mm, 70-210mm, and 75-300mm models. As you can see, some of these zooms overlap into other focal-length ranges. Up to about 150mm (picture angle 16°), lens characteristics remain similar to the 135mm focal length; settings between 150mm and 180mm are more closely related to the telephoto range.

Telephoto Lenses (180mm-300mm)

Lenses with focal lengths between 180mm and 300mm are used from even greater distances and display

A 180mm lens is well suited for travel photography.

distinct telephoto characteristics: compression of space, narrow angles of coverage, and shallow depth of field. In photographs taken from intermediate distances, relatively small objects will fill the frame. On the other hand, these focal lengths are not quite long enough to span great distances. Zoo animals, for instance, may fill the picture area, while those in the wild will not. Compared with a 50mm lens, magnifications for this range are from 3.6x (at 180mm) to 6x (at 300mm).

By comparison, standard binoculars magnify vision by about 8x.

Telephotos are fine tools for landscapes, such as a frame-filling mountain or a rock wall. In architectural photography, distant details (for instance a gable) can be captured, or a row of houses compressed into a stack. Candid portraits or concert shots are also possible from considerable distances. Sports and wild-animal photography often requires still-longer lenses, unless you want to include the surroundings as well.

The classical telephoto range includes the following focal lengths: 180mm (picture angle 14°), 200mm (12°), 250mm (10°), 280mm (8.5°), and 300mm (8°). Typical zooms covering this range include 50-300mm, 60-300mm, 75-300mm, 100-300mm, 150-500mm, and 200-500mm. At these focal lengths, apochromatic or near-apochromatic optical correction can visibly enhance definition and contrast rendition.

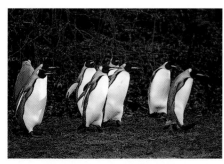

The photographer kept his distance and used a 280mm lens so as not to disturb the strolling penguins.

With a 300mm lens you can pick out details on the rooftops of buildings.

Prime lenses of 180mm, 200mm, or even 250mm, as well as some of the zooms, tend to be fairly compact. Even so, hand-held shots are best made at 1/500 second or higher if maximum image quality is required. Because camera shake is magnified along with the image, using 1/250 second (as suggested by the well-known "focal-length reciprocal" rule) is actually somewhat risky. In any case, the camera-lens combination should be well balanced and fit comfortably in your hands.

With very fast telephoto lenses (such as a 180mm $f/2.8$ or 200mm $f/2$), spherical aberration may be noticeable at short distances and full aperture settings. To ensure sharp picture edges, close the diaphragm to $f/4$, or even $f/5.6$ if possible. (Of course, with a centrally located subject, the edges may be out of focus anyway, due to limited depth of field.) For manual focusing, a completely matte screen is advisable.

These fast lenses are ideally suited for available-light work, such as theater and concert photography, animal photos in dim surroundings, and landscapes at dawn or dusk. Some models have

close-focusing capabilities that allow you to capture details of architectural or industrial subjects.

Especially important for 250mm, 280mm, and 300mm lenses is a rotatable tripod collar, with click-stops at the vertical and horizontal positions. The camera's own tripod socket, however, should never be employed when a heavy lens is attached. Similarly, your neck strap should always be connected to the lens' eyelets, not to the camera's. These precautions will ensure the safety of the lens and of the camera body, particularly the bayonet mount.

Great care should also be taken to focus accurately and to release the shutter without causing any vibration. Shallow depth of field at full aperture creates a distinct separation of sharp and out-of-focus areas, ideal conditions for AF systems or a full-matte focusing screen. Whenever possible, mount the equipment on a sturdy professional-type tripod and lock the

mirror up before each exposure. For sports and wildlife photography, a monopod is a good compromise. If hand-held shooting is necessary, set the shutter to at least 1/1000 second for a reasonable expectation (but no guarantee) of absolutely sharp pictures.

Lenses of 280mm or 300mm with speeds of f/2.8 or faster have very large front elements, which many photographers protect with an ultraviolet or skylight filter. We advise against this practice except in extremely adverse conditions, because it may increase light reflections and reduce contrast. Under normal circumstances, the lens hood, scratch-resistant coating (on

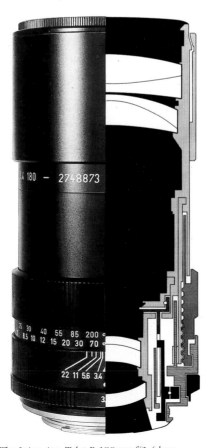

For taking snapshots from a greater distance, try a 200mm lens.

The Leica Apo-Telyt-R 180mm f/3.4 lens

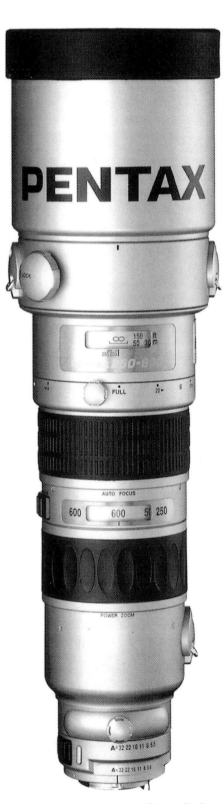

The SMC Pentax-FA Zoom 250-600mm f/5.6 ED IF is one of the few zooms in the extreme telephoto range.

Detailed photographs of wildlife require extreme telephoto lenses.

When traveling, photographers often want to avoid carrying around heavy lenses, such as extreme telephotos. One solution is to use tele-converters. These shots were made with a 180mm lens and a 2x teleconverter, resulting in an effective focal length of 360mm.

high-end lenses), and reinforced lens barrel edges are enough to prevent damage.

Extreme Telephoto Lenses (300mm-1200mm)

The most powerful lenses of all, extreme telephotos, with focal lengths between 300mm and 1200mm, are ideal for spanning long distances. They offer magnifications of 7x-24x (compared with 50mm) and are well suited for wildlife, sports, and landscape photography. Because of the great shooting distances, perspective is extremely compressed, creating striking visual effects.

The most common focal lengths in this range are: 350mm (picture angle 7°), 400mm (6°), 500mm (5°), 600mm (4°), 800mm (3°), 1000mm (2.5°), and 1200mm (2°). Zoom lenses, however, only cover focal lengths up to 600mm. A few lenses with focal lengths of 350mm, 400mm, or even 500mm can be handled quite comfortably, if your arms are strong enough. Thanks to an internal-focusing design, they usually offer smooth manual focusing or even autofocus.

For ease of handling, the physical length of extreme telephoto lenses is usually less than their focal length. This requires an asymmetrical arrangement of lens elements and great effort to correct aberrations. The difficulty in correcting chromatic aberration is common to both telephoto and extreme telephoto lenses. This "secondary spectrum" may cause noticeable color fringing, which we perceive as reduced sharpness and color saturation. The effect can only be reduced effectively in the extreme focal-length range with newly developed, highly refractive glass.

Even a well-corrected telephoto lens' impeccable performance can be impaired all too easily by atmospheric effects, such as haze or heat streaks. Other causes of reduced sharpness include camera shake and subject movement during the exposure. At high magnifications, even a tripod-mounted camera and lens may be affected by a strong breeze or by the movement of the mirror (if it was not locked up). It is foolhardy to handhold such long lenses, because even the slightest vibration will impede their sharpness. Once again, you are better off shooting from a sturdy, professional-type tripod and locking up the mirror whenever possible. If weight is a factor, a monopod can hold lenses up to 500mm more

steadily than a typical amateur tripod. This is because a firmly held monopod absorbs small vibrations caused by the wind, the diaphragm, and the shutter, while flimsy tripods have a pronounced tendency to swing along with every induced movement. Avoid using a monopod on 600mm or longer lenses, however, unless it is employed solely as a support for the lens barrel, in addition to a sturdy professional tripod. Rather than using the tripod mount on the camera, be sure the one on the lens will facilitate easy changing between horizontal and vertical-format shooting.

Manual focusing is especially critical with very long focal lengths and should only be done with the help of a completely clear matte screen. Several lenses offer AF as well. In most cases a lens hood is supplied to protect the large front element from stray light and mechanical damage. When not in use, the hood can generally be mounted in a storage position.

Front and rear sights may be integrated into the lens grip, to serve as an action finder. This makes it possible to quickly locate the often tiny subject area covered by the picture angle of the lens.

Extreme telephoto lenses are often designed with a preset-focus feature, which lets you instantly recall a set focusing distance. It is particularly useful for sports

photography, allowing the photographer to preset focus on an area where action is likely to occur, such as second base. The lens can be used as usual, but if sudden action occurs at the set focus distance, the photographer need only point the camera and activate the preset focus.

In addition to sports, telephoto lenses of 400mm-600mm are used for photographing animals in the wild or for landscapes where an important detail is to be isolated. These lenses can be used for fashion and advertising work as well, using their shallow depth of field and characteristic perspective to deliberately create unusual effects.

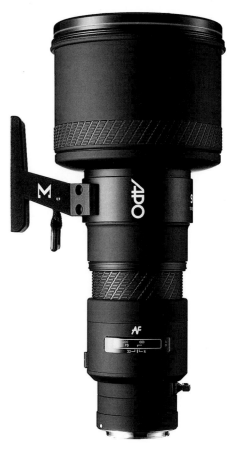

The Sigma AF 500mm f/4.5 Apo ZEN lens

A long-distance lens, the Leica Telyt-S 800mm f/6.3 is designed with just three cemented lens elements made of special glass. Therefore, it has only two air-to-glass surfaces.

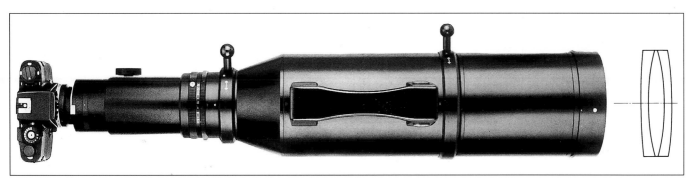

Special-Purpose Lenses

Special-purpose lenses allow the SLR photographer to handle unusual tasks such as extreme close-ups, architectural work with perspective correction, soft-focus portraiture, or fisheye imaging. In the telephoto realm, this category includes mirror lenses and tele-converters.

The distinct compression of space due to a long focal length and the so-called "doughnut-shaped" blurred rings typically caused by mirror lenses can be intentionally employed as a means of composition.

Mirror Lenses

Catadioptric, or mirror, lenses are a special type of telephoto that use a "folded" light path to encompass a very long focal length in a surprisingly compact enclosure. The light beam enters through a large, ring-shaped lens element and is reflected by the ring-shaped main mirror onto a smaller, secondary mirror. This mirror then reflects the light back through the other lens elements onto the film.

Due to its unique construction, a mirror lens cannot accommodate a variable diaphragm. The stated lens speed is the only possible aperture setting. Typically, mirror lenses are very slow, $f/8$ or $f/11$ being the most common f-numbers. While this may be problematic in some instances, these lenses are usually mounted on a tripod, which allows for slower shutter speeds. The most limiting feature of a mirror lens is that the fixed aperture gives the photographer no way to control depth of field.

For the most part, exposure is controlled with the shutter speed. If the light is too bright, even at the highest available speed, a neutral-density (ND) filter can be attached.

For example, a 4x ND filter reduces light intensity by two stops. Such filters influence only the *amount* of light, not the depth of field, which continues to be determined by the fixed aperture, the focal length, and the camera-to-subject distance. Mirror lenses from some manufacturers include a filter in their optical formula. This means that for optimum performance some filter must be in place any time the lens is used.

Thanks to their unique design, mirror lenses are virtually free of chromatic aberration. You might, therefore, expect them to have excellent definition and contrast rendition. In practice, however, there are substantial differences from one manufacturer to another.

Mirror lenses also tend to display slight vignetting, which cannot be overcome by stopping down the diaphragm (because there is none). This vignetting may be annoying, especially with evenly lit subjects or with slight underexposure.

Optical correction of these powerful telephotos is greatest at moderate-to-long distances, although some are capable of close focusing as well. For example, the Reflex-Nikkor 500mm $f/8$ focuses to about five feet (1.5 m), resulting in a

reproduction ratio of 1:2.5. As you know, a mirror lens' optical performance cannot be improved by stopping down, so a slight reduction of close-up image quality is inevitable.

Since depth of field is limited by the maximum aperture, focusing accuracy is critical. Therefore, the use of an overall-matte focusing screen is strongly recommend. Especially in dim light, accurate focusing can be difficult, which is a good reason to mount the mirror lens (or the camera) on a sturdy tripod. In fact, for top results these lenses should *always* be used with a stable tripod.

Although mirror lenses are compact and easy to handle, there is considerable danger of camera shake, due to their focal length (500mm or 1000mm) and light weight. This is also true for shots from monopods. A heavy, conventional 400mm $f/2.8$ lens will mount solidly on a monopod, while a much lighter mirror lens cannot prevent the setup from swaying.

Like all telephoto lenses used at long camera-to-subject distances, mirror optics give a distinct sense of flattening or compression of space. Unique to this design, however, are "doughnut-shaped" out-of-focus highlights in the foreground or background, caused by the ring-shaped mirror and front element. These "doughnuts" are quite distinctive and can be used as a means of creative expression in your images. Natural subjects for mirror lenses include travel and landscape photography (particularly for the 500mm focal length) and wild animals (with the 1000mm).

Many manufacturers offer 500mm $f/8$ mirror lenses. Other models include the Sigma 600mm $f/8$ ZEN, the Reflex-Nikkor 1000mm

$f/11$, the SMC Pentax Reflex 1000mm $f/11$, and the SMC Pentax-M Reflex 2000mm $f/13.5$ (one of the longest mirror lenses available). Pentax also offers the only zoom mirror lens we know of, the SMC Pentax Reflex Zoom 400-600mm $f/8$-12. Mirror lenses with the previously common focal length of 250mm are only available on the secondhand market. A few mirror lenses are produced on special order, such as the powerful Reflex-Nikkor 2000mm $f/11$, with an angle of view of just over 1°.

Perhaps the most unusual mirror lens is the special-order Zeiss N-Mirotar 210mm, with an effective speed of $f/0.03$! This is not a typo; the lens is really *2500x* as fast as a normal $f/1.4$ lens, or *11 stops* faster. This remarkable performance is possible because the N-Mirotar combines a fast telephoto lens with a three-stop electronic light amplifier. Also, its image-area diameter is only 30 mm, so it does not cover the complete 35mm format (which requires an area of about 44 mm). And the price is beyond belief.

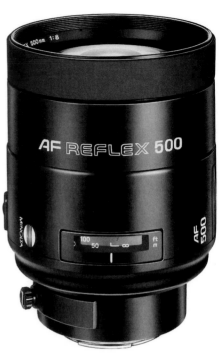

A mirror lens with autofocus: The Minolta AF Reflex 500mm f/8 lens

Teleconverters

It may seem strange to discuss teleconverters, also called extenders, as if they were lenses. But most converters are, in fact, lenses with a "negative" focal length. Really good teleconverters incorporate high-class optical systems with five to seven elements, and they may even be apochromatically corrected. Converters extend the focal length (and reduce the speed) of the attached lens by a constant factor, usually 1.4x or 2x.

Teleconverters are intended for use with lens focal lengths greater than 50mm. They are generally

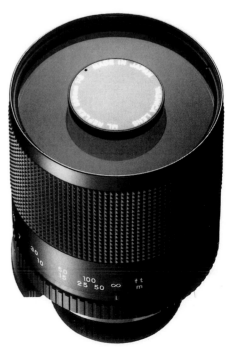

The Yashica ML Reflex 500mm f/8 lens

Their relatively compact size and long focal lengths make mirror lenses excellent for travel and wildlife photography.

Both of these pictures were taken with the Leica Apo-Telyt-R 280mm f/2.8 and Apo-Extender-R 1.4x. The Apo-Extender converted the lens into an Apo 400mm f/4 lens.

used with prime lenses, rather than zooms, and focal lengths of 100mm or more. Keep in mind that a 2x extender—the most common type—requires a two-stop increase in exposure. This can be done by opening the lens diaphragm and/or by using a slower shutter speed, with increased danger of camera shake. Whenever possible, a plain-matte screen should be used for focusing; some models allow AF operation as well.

Aperture numbers and depth-of-field scales engraved on the lens are not valid with a teleconverter in place. If, for instance, a 100mm $f/2$ lens is turned into a 200mm $f/4$ by a 2x converter, the marked aperture of $f/2$ represents an effective opening of $f/4$ (at the new focal length). Generally, the automatic diaphragm will continue to operate, along with the auto-exposure and (often) the autofocus system. To ensure correct exposure, converters should be used on cameras with through-the-lens meters, a category that includes virtually all modern SLRs.

An extender not only increases the power of a telephoto lens, but its close-up capabilities as well. While the focal length is (usually) doubled, the shortest focusing distance remains the same, resulting in a doubling of the reproduction

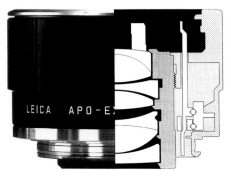

The Leica Apo-Extender-R 1.4x preserves a lens' apochromatic correction.

ratio. Optical quality does not match that of a true macro lens, but it is usually acceptable.

Because converters are optical systems placed in the lens' path, they inevitably cause some loss of definition and contrast. The amount of loss depends on how well the converter is corrected and even more on whether it was designed specifically for the attached lens. Inexpensive converters that claim to work equally well on virtually any telephoto lens can cause problems.

For best results, choose a converter made especially for your lens, or at least for a certain span of focal lengths. In any case, the edges of the image are more strongly affected than the center; closing the diaphragm by two stops usually improves image quality markedly. On the other hand, this will require a slower shutter speed, with more risk of camera shake.

Converters are a good compromise for photographers who only rarely need the focal length achieved by using them. Also, a travelling outfit can be kept small by replacing one or several focal lengths with converters. High quality converters can even help a wildlife photographer avoid purchasing an expensive lens, perhaps by converting a 400mm $f/2.8$ telephoto lens into an 800mm $f/5.6$.

Macro Lenses

Macro lenses are versatile: They can be used exactly like conventional models of the same focal length or serve as high-quality close-up lenses. Depending on the lens' design and focal length, reproduction ratios up to 1:2 or 1:1 (half or full life-size, respectively) can be achieved without accessories. Some

A well-corrected macro lens should be employed for still lifes whenever the best possible definition is demanded at close range.

macro lenses are provided with adapters or front-mounted optics to extend the focusing range from 1:2 to 1:1. Special close-up equipment, such as a bellows unit or extension tube, enables you to achieve even greater magnifications. In addition, some manufacturers offer lenses with magnifications up to 16x for extreme close-ups.

The most common focal lengths for macro lenses are 55mm, 60mm, 100mm, and 105mm. There are also a few lenses in the wide-angle (28mm) or telephoto (200mm) range with true macro focusing. However, camera-to-subject distances for a macro-focusing wide-angle tend to be inconveniently short, while they may be overly long with a 200mm macro telephoto. Which focal length to choose depends on your application.

Tables supplied by the manufacturer give the reproduction ratios and working distances for each lens, with and without accessories. In many cases, a greater working distance makes it easier to illuminate the main subject; it also makes small animals or insects less likely to flee.

The designation "macro" is also used on zoom lenses, in a

The Minolta AF Macro Zoom 3x-1x (1:1.7-1:2.8) is an autofocus macro-zoom allowing reproduction ratios between life size and 3x magnification to be set steplessly.

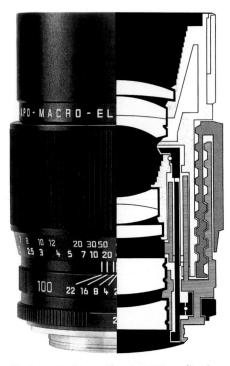

The Leica Apo-Macro-Elmarit-R 100mm f/2.8 lens

widespread and rather misleading way. Most zooms, especially at their short focal-length settings, have limited close-focus capabilities. For example, a 28-80mm zoom may only focus to six feet (2 m) at the 28mm setting. The "macro" feature simply introduces a close-up lens or extension into the optical path, reducing the zoom's shortest focusing distance to that of a comparable fixed focal length lens.

Several companies offer lens "heads," designed to be attached to bellows units. Some lenses intended for high reproduction ratios can also be mounted on a bellows, generally in a "retro" or backward position. These lenses are available in different focal lengths, designed to achieve the best possible image quality at varying degrees of magnification.

Perspective-Control Lenses

When used with care, converging lines can enhance the dramatic impact of a photograph. However, when these lines appear accidentally—as they often do—the picture can easily be ruined. Converging lines occur when the camera (and therefore the film plane) is not parallel to the subject. A common example is when a photographer tilts the camera to include all of a high-rise building in the frame. This causes normally parallel lines to appear to slant toward each other or even to meet near the top of the image.

There are several ways to avoid converging lines:

1. Find a more elevated shooting position, perhaps on an upper story of a facing building rather than in the street.

2. Tilt the negative or the easel during the enlarging process.

3. Shoot with an extreme wide-angle lens, then crop the image as desired.

All three of these methods have obvious drawbacks. The first approach may not be possible, and the other two entail significant losses of image quality. The best way to avoid converging lines is to keep the film parallel to the subject and adjust the composition with a "shift" or perspective-control (PC) lens. Such lenses, usually wide-angle models, have an unusually large image area. A geared mechanism enables the optical system to be moved away from its original axis, to include parts of the subject that would otherwise be outside the image area.

It is vital to align the camera carefully before shifting. This can be done with a bubble level or by using a focusing screen with an etched line-grid. Depending on the camera-to-subject distance, shifting just a fraction of an inch may move the image field by several yards. The changing image field can be observed in the viewfinder, of course, or calculated with the following equation (which works best using metric measurements):

$$\frac{S}{F} \times D = M$$

Where:

S = Shift (in mm)
F = Focal Length (in mm)
D = Focusing Distance (in m)
M = Movement of the Image Area in the Object Plane (in m)

Here's an example for a PC lens with a focal length of 28mm, shifted by 11 mm at a focusing distance of 50 m:

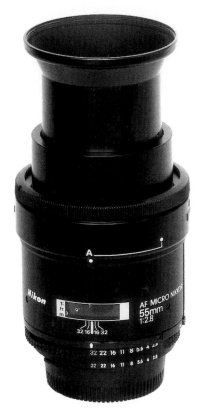

The AF Micro-Nikkor 55mm f/2.8 lens

$$\frac{11}{28} \times 50 = 19.64 \text{ m}$$

In this case, shifting the lens by 11 mm results in a movement of almost 20 meters in the object plane. This is the equivalent of moving the camera from the street to the sixth floor of a facing building!

PC lenses can be shifted vertically, horizontally, or even diagonally. The horizontal and diagonal shifts are particularly effective if you are forced to occupy a position at the side of a building, perhaps to avoid a reflection or an obstacle. Advertising photographers also use

PC lenses to render products with an attractively "natural" perspective.

Because 35mm cameras do not offer the front or rear standard movements available in view cameras, shift lenses represent the best way to influence perspective. As you may know, view cameras also permit a "tilting" movement, which can expand or contract depth of field according to the rules codified by Scheimpflug. This valuable movement is not available in 35mm, except for the unique Canon TS-E "tilt and shift" lenses, to be discussed later.

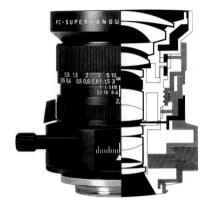

The Leica PC-Super-Angulon-R 28mm f/2.8 lens can be shifted 11mm in any direction.

Controlling perspective and converging lines with a 28mm shift lens:

Converging lines result due to the film plane being tilted backwards; the lens is not shifted.

The film plane is parallel to the object plane; the lens is not shifted.

The image area is optimized by shifting the lens 10mm upwards.

Shift lenses are not only used to correct converging lines, but they also enable you to take frontal shots of subjects that are otherwise not so easily accessible.

Because the view was obstructed by a hedge and a pile of boards, the camera had to be positioned to the side and at an angle to the subject.

When the camera was aligned parallel to the subject, the taking position was too low and too far to the side.

By shifting the 28mm lens diagonally, it was possible to optimize the image's composition.

The Pentax SMC-F Fisheye Zoom 17-28mm f/3.5-4.5 lens

The Canon TS-E 24mm f/3.5 L is one of three Canon lens models that allows the optical axis to be both shifted and tilted.

Common PC focal lengths are 28mm (which offers the greatest amount of object movement) and 35mm. A good example of the former is the PC-Super-Angulon 28mm *f*/2.8, made by Schneider in Leica-R and Rolleiflex mounts. This lens has a usable image-area diameter of 62 mm, almost 20 mm more than the diagonal of the 35mm format. Therefore, the optical axis can be shifted 11 mm horizontally or 9.5 mm diagonally. Although the PC-Super-Angulon displays good definition and contrast wide open, performance is even better at *f*/4 or *f*/5.6. And when large shifts are employed, an aperture of *f*/8 or *f*/11 is required for optimum results. Thanks to floating elements, image quality is excellent even at close range; vignetting and distortion are also well controlled. Diaphragm action is manual, so TTL metering must be done in the stopped-down mode. In addition, a correction factor of +1/2 EV is necessary for shifts greater than 9.5 mm.

For many years, Nikon has been known for its perspective-control lenses. The 28mm *f*/3.5 PC-Nikkor offers 74° picture coverage, 11 mm off-axis shift, and 360° rotation. A more compact version, the 35mm *f*/2.8 PC-Nikkor, has the same shift capabilities and a 62° picture angle.

Finally, the Canon TS-E lenses can be tilted as well as shifted. Each one offers up, down, and sideways movements comparable to other PC lenses. In addition, a special lens mount allows the image axis to be tilted, increasing the available depth of field.

Briefly, if the object, lens, and film planes meet in a mutual line, everything within the object plane will be depicted in focus. So even with the lens wide open, you can achieve front-to-back sharpness. To achieve an unusual effect, you may

also want to try tilting the lens in the opposite direction, which radically *reduces* depth of field. While the TS-E lenses do not offer the full-tilt possibilities of a view camera, they greatly expand the horizons of 35mm photography.

Fisheye Lenses

Fisheye lenses display very strong barrel distortion, which bends all horizontal and vertical lines not passing through the image center. Only those lines exactly in the middle remain straight; the further the lines are from the center, the more curved they are. Also, flat surfaces such as walls are rendered with a dish shape.

Fisheye lenses are available in focal lengths from 6mm to 16mm. The shorter lenses, including 6mm, 7.5mm, and 8mm focal lengths, give extraordinarily wide coverage, ranging from 220° to 180°. Because they do not cover the entire 35mm frame, these fisheye images create circular images with the familiar "Christmas tree ornament" look. Fisheyes with focal lengths of 15mm or 16mm also have a 180° diagonal picture angle, but with full-frame image coverage. The effect is similar to a panorama, if there are no obvious straight lines to be distorted. (Panorama cameras create their own distortion, but that's another story.) Great care should be taken not to include the tips of your shoes in fisheye pictures—something that happens more easily than you might think.

In general, narrow-angle or spot light-metering modes work best with these lenses, because their extreme angle of view tends to encompass subject areas of wildly different brightness values. And with the shorter fisheyes, the dark

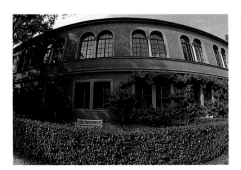

A fisheye lens will reproduce a flat facade with a bulge.

Only someone familiar with this location will recognize that this shot was taken with a fisheye lens. The water's edge in front of the palace is straight and not curved. This picture clearly demonstrates that a fisheye lens renders lines that run through the center of the image as totally straight.

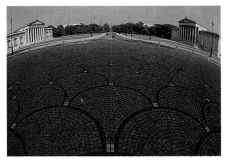

A typical fisheye shot, easily identified by the extreme angle of view and the curved rendition of straight lines.

edges beyond the circular image area may cause an averaging meter to overexpose. A good fisheye lens will exhibit no apparent vignetting, and most have integrated wheels containing four or five filters. These lenses are especially suited for landscape photography or experimental architectural work. Beyond that, scientists often employ fisheyes for images of extremely cramped spaces, such as the inside of an industrial pipe. The widest such lens is the special-order Fisheye Nikkor 6mm *f*/2.8, whose 220° angle of view actually allows it to "see" behind the photographer. Believe it or not, there is even a zoom in this category. The new Pentax SMC-F Fisheye Zoom 17-28mm *f*/3.5-4.5 ranges from 180° to 90° coverage at a touch of the zoom ring.

Apochromatic Lenses

Apochromatically corrected lenses are not obviously unusual, like fisheye or mirror lenses. They do, however, offer something special. Not long ago, the designation "apo" was a kind of shorthand for the highest image quality, referring to lenses corrected for all three primary colors rather than only two.

Now its meaning is questionable. More and more lenses are adorned with what used to be an elite designation, without necessarily offering true apochromatic correction. Call it word inflation: Just as a fashion model somehow becomes a supermodel, an ordinary achromatic lens can now be called an apo. But the latter term, at least, really has meaning, as we shall see.

What Does "Apo" Mean?

What we perceive as "white" light actually consists of three additive primary colors—red, blue, and green. As light passes through a lens, it acts like a prism, separating the light into various colors. Each color has its own wavelength and is therefore subject to a different amount of refraction (bending) as it passes through. For example, short-waved blue rays are deflected more strongly than long-waved red ones. This color defect, called chromatic aberration, causes the three primary colors to come into focus at different planes, which may be in front of or behind the film plane. If left uncorrected, the result is an obvious lack of sharpness and contrast.

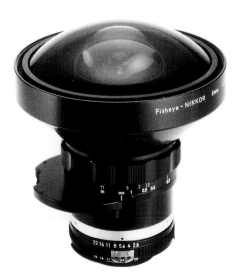

The Fisheye Nikkor 8mm f/2.8 produces a circular image on the film and has a picture angle of 180°.

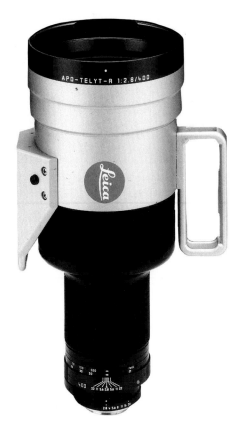

The Leica Apo-Telyt-R 400mm f/2.8 lens

The Minolta AF Apo Tele Zoom 80-200mm f/2.8 lens

Chromatic aberration escalates with increasing focal length and lens speed, so fast telephotos are especially susceptible.

Most lenses are achromatic, or corrected for two primary colors to come to focus on the same plane. The remaining, uncorrected "secondary spectrum" color defects may cause color fringing, which we perceive as a soft, flat look. An apochromatic lens, however, is corrected for all three primary colors, united in focus on one plane. The more complete the correction, the better a lens' definition and contrast rendition will be.

The secondary spectrum can be reduced to a negligible amount but only with special, expensive types of glass that are exceptionally high in refraction and especially low in dispersion. Such high-index glass (termed ED, LD, UD, or EL-D, depending on the maker) is routinely used on top-quality, apochromatically corrected lenses.

Sadly however, the designation "apochromat" is not defined by the ISO (International Standards Organization) or by any national equivalent. So it is up to each manufacturer to use the term as it sees fit. As a positive example, several

Nikon lenses are denoted as "ED" (Extra-Low Dispersion) types, rather than as apochromats. Yet they achieve an unusually high level of color correction, which would surely cause a less-scrupulous company to apply the apochromatic label.

What Does "Apo" Achieve?
The idea that "apo" lenses offer better image quality than conventional models is only conditionally true. Our experience can be summed up as follows:

— A lens labeled "apo" should be, but does not necessarily have to be, superior to an achromatic model. While the apochromatic designation suggests a well- or even superbly corrected lens, the degree of truth depends on the supplier's honesty.

— True apochromatic correction, reducing the secondary spectrum to insignificance, can only be realized in long focal lengths at great expense. Extremely costly glass variants are required, as described above. So beware of cheaply priced "apo" lenses.

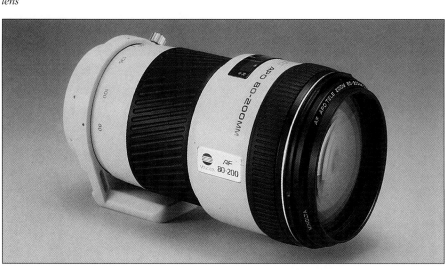

— Practical experience tells us it is necessary to accurately define or standardize the term "apochromatic." Until the parameters of apochromatic correction are precisely determined, there is no way to deduce the degree of correction of an "apo" lens.

Before purchasing an apochromatically corrected lens, consider whether you really need it. Photographers using color negative films to make 4x6 or 5x7 prints will hardly see the difference. And if most of your work is portraiture, a lesser lens may actually be preferable—your subjects will be grateful for the reduced sharpness. However, if you require the utmost in lens performance, an apo may well be worthwhile.

Every lens achieves its best image quality at the focusing distance for which it was corrected. For telephotos, this generally means infinity. In practice, however, we use most lenses at a variety of distances. With true apochromatic correction, excellent results can be achieved over the complete focusing range, even with the aperture wide open.

Photographers often use moderate aperture settings to achieve the desired depth of field and improve overall performance. Beyond a certain point, however, choosing a smaller aperture begins to reduce sharpness, due to the effects of diffraction. Therefore, the working aperture should be chosen carefully. With conventional lenses, stopping down by two or three stops usually produces the best results. For an apo lens, however, one stop down from wide open is usually enough. Closing the diaphragm further will not enhance the image quality; at $f/8$ or $f/11$, the lens' performance may deteriorate visibly.

Apo lenses are admittedly expensive, and for good reason. They operate at a level where slight improvements of an already excellent image are difficult to achieve. Quality cannot be quantified as simply as price, so a lens costing twice as much as another may not perform twice as well. Only you can decide if it's worth the cost.

Whenever the highest image quality is required, apochromatically corrected lenses are the best choice.

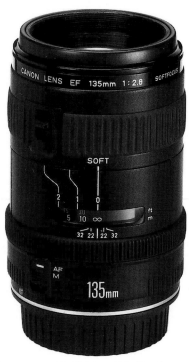

The Canon Softfocus EF 135mm f/2.8 lens

Soft-Focus Lenses

Soft-focus lenses are, in a sense, the opposite of apo models. Their defining characteristic is a *lack* of correction, specifically of spherical aberration. The classic example of a true soft-focus lens is the Rodenstock Imagon, with a rotating, perforated disk to control the softening effect. Sadly, the 135mm Imagon for the 35mm format is not generally available, nor is the well-regarded SMC Pentax Soft 85mm *f/2.2*.

Fortunately, several soft-focus lenses are still available, including the Canon Softfocus EF 135mm *f/2.8*, the Minolta Softfocus 100mm *f/2.8*, and the Nikkor 135mm *f/2* AF-DC. These lenses are capable of producing sharp pictures, or you can select the desired softening effect by turning a ring. As true soft-focus lenses, they actually create a sharp image, surmounted by a greater or lesser degree of unsharpness.

This effect is quite different from that produced by accessories such as a fog filter, nylon stocking, or glass plate smeared with Vaseline. Pictures made with such accessories added to a lens are unsharp, however they do not exhibit the high-quality optics evident in images made with soft-focus lenses. Image-softening filters and accessories are available in many colors and produce many different effects (such as vignetting). With a few of these in hand, the photographer can experiment at relatively low expense compared to investing in a soft-focus specialty lens.

But whatever approach you take to soft-focus, don't stop the lens down past about *f/5.6*. This would lessen the softening effect by reducing the amount of spherical aberration.

Soft focus is quite popular for portraits, particularly of women, and for romantic landscapes and still lifes. In fact, it is probably used too often. Consider the effect carefully before using it to avoid producing a visual cliché.

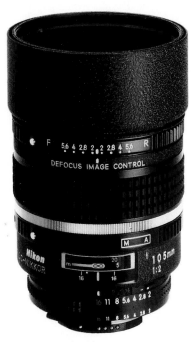

The soft-focusing lens from Nikon: The Nikkor 105mm f/2 D AF DC lens

Perspective

How perspective is treated in a photograph frequently determines the image's visual impact. The rules of central projection, camera location, and subject distance can be used to manipulate the look of a photo and create exaggerated perspective for a strong, three-dimensional composition or to flatten a scene and minimize the sense of space between elements in the photograph.

Many factors contribute to the success of an image. To start, focusing must be accurate, which requires an appropriate screen and a well-adjusted viewfinder. With AF lenses, the focusing point should be selected carefully. The chosen aperture also has a decisive influence on image quality, in terms of sharpness and depth of field. Equally important is the shutter speed, which must be matched to the lens' focal length and the subject's motion. Naturally, image quality also depends on proper exposure of the particular film in use.

For our purposes, however, the photographer's most important consideration is the selection of a lens focal length. This choice radically alters the "look" of your images, based on the rules of perspective.

In simple terms, perspective is the two-dimensional depiction of three-dimensional objects. Photographic perspective encompasses not just one subject, but numerous subjects of varying size and distance, anywhere in the three-dimensional space to be reproduced in an image. Despite

common misconceptions, perspective is *not* determined by the lens but exclusively by camera location and subject distance. (Large-format cameras also allow the perspective to be influenced by tilting and swinging the lens standard.)

Rules of Central Projection

The spatial, three-dimensional illusion in photography is created according to the rules of central projection. This flows from two important concepts: *Foreshortening* means that identically sized objects are pictured increasingly smaller as their distance from the camera increases. *Convergence* creates the illusion that parallel lines running along the lens axis converge at a single point.

Let's start with foreshortening—objects of the same size reproduced at different sizes, depending on their distance from the film plane. This means that objects closer to the camera seem large, while more distant objects look small. The effect is especially obvious at short

When two walls that are positioned at an angle to one another are photographed from their vertex, the vanishing lines will meet at two secondary vanishing points. (However the vanishing points may not fall within the image frame.)

Here are two different perspectives: the first taken from normal eye level and the second from the bell tower.

75

Parallel lines that are aligned vertically on the image plane and run along the lens axis meet at the image's main vanishing point.

Parallel lines that run at an angle across the image plane meet at a so-called "secondary" vanishing point.

Note the bridge's vanishing lines and the fore-shortening of its identically sized girders.

The railroad ties, which run parallel to the film plane, are rendered parallel in the picture. The tracks, which are aligned vertically on the image plane, converge at the vanishing point.

camera-to-subject distances and is much less noticeable at long ones. That's why foreshortening is strongest in wide-angle shots that include clearly identifiable objects in the foreground and in the background. A stone, for instance, photographed with a 21mm wide-angle lens from eight inches (20 cm) may look like a boulder; likewise, a far-away boulder will look like a pebble. This effect is all too apparent in a full-face portrait made with a wide-angle lens, creating a caricature of the person, with a huge nose and distorted features.

The rules of central projection also determine the appearance of converging or "vanishing" lines. In effect, the lens becomes the center of perspective, equivalent to the human eye. Parallel straight lines running near the lens axis appear to meet at a distant "vanishing point." This impression occurs, for example, when you photograph a set of railroad tracks. If the tracks run nearly vertical to the image (along the lens axis, straight away from your eyepoint), they seem to converge in the distance.

All parallel straight lines join at a single "vanishing point" or "main point," created by perspective projection onto the flat image. This vanishing point, located exactly on the center of perspective, also determines the location of the horizon line. That's why the horizon line varies with the height of the lens.

The example of the railroad tracks reveals something more: The cross-ties on the tracks, aligned parallel to the image plane (and perpendicular to the lens axis), are depicted as being parallel. In fact, straight lines running parallel to the image plane always remain parallel in photographs, because their vanishing points lie at infinity. This is true for vertical, horizontal, and inclined straight lines, as long as they are aligned parallel to the image plane—a characteristic that's vital for achieving a natural look in architectural photography.

Picture Angle and Perspective Distortion

One of the most important features of central projection is the faithful depiction of straight lines. Nothing other than a straight line is ever rendered as such, and only a line running precisely along the optical axis is pictured as a point. Any well-corrected lens will reproduce a straight line exactly that way, regardless of the focal length. (An exception is the fisheye lens, with its purposely uncorrected barrel distortion.)

A classic example of perspective distortion concerns the converging lines that occur when the image plane is tilted upward, perhaps to capture a tall building. The same effect occurs when you photograph a building from a higher position shooting down; only this time, the building walls appear to converge toward the base of the building.

Such converging lines are nothing more than the familiar vanishing lines, transposed to the vertical plane. Imagine our familiar set of railroad tracks running up the side of the building, and you've got the picture.

Perspective distortion should not be confused with an optical defect that causes straight lines to be depicted as curves. This problem is the result of spherical aberration, often caused by a poorly placed lens diaphragm. Perspective distortion, on the other hand, is not an image defect and cannot be corrected by improving the lens design.

With ultra wide-angle lenses, you

may notice that objects at the edges and corners of the image look distorted. This effect can be divided into linear and elliptical types, depending on the subject. Linear distortion of rectangular objects follows the rules of central projection. Therefore, a well-corrected wide-angle preserves the appearance of vanishing lines so that straight lines stay that way. But the larger the picture angle, the steeper the angle at which the vanishing lines are reproduced.

Round objects situated at the image edges, and especially in the corners, are subject to elliptical or "egg-shaped" distortion. This distortion also becomes more pronounced at increasing picture angles, near the edges and corners of the image. Both types of distortion are most noticeable at short camera-to-subject distances.

Interchangeable Lenses and Perspective

As stated earlier, the composition and expressiveness of your images are profoundly influenced by perspective. Contrary to common belief, this perspective is exclusively determined by the camera position and subject distance, *not* by the focal length or picture angle of the lens. Nevertheless, the ability to vary the angle of view makes it possible for you to choose the best picture-taking position, creating the desired perspective.

Perspective and its distortion determine whether an object will be rendered naturally or misshapen. That's why distortion has important consequences for both indoor and outdoor photography. We will illustrate this point with some examples, which you can easily reconstruct.

The main vanishing point where the parallel lines meet is clearly recognizable.

A natural-looking, undistorted picture is best realized with a normal or medium telephoto lens that is not positioned very close to the subject. The main subject and its surroundings are rendered with proper shapes and relative sizes, and the vanishing point is back far enough so that perspective is not exaggerated. An eye-level camera position and film placement parallel to the subject also contribute to a natural appearance.

Conversely, the best way to achieve a strikingly "interpretive" depiction of a subject is to use a short focal length at close range. With a short focusing distance, the vanishing point is shifted toward the front, and the converging lines are quite steep. Everything near the camera is presented at an exaggerated size, while distant objects appear far too small. This unusual view of things can be further emphasized by tilting the camera.

When choosing focal length and focusing distance, the shape of the subject is also an important consideration. In the set of photos on page 78, the lenses are pictured naturally, with a 180mm and 100mm lens. Their barrels appear cylindrical and parallel to each other, and the front elements and filter threads are properly round. For a completely different effect, photographs were taken of the same subjects with a 15mm ultra

The strong impression of space in these two photos was achieved by using a 21mm ultra wide-angle lens to emphasize the foreground.

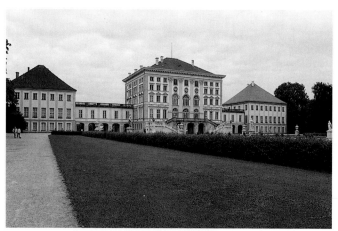

Photographed slightly from the side, this chateau is depicted according to the rules of central perspective; the vanishing lines converge at the chateau's facade.

Here the film plane is aligned parallel with the chateau and the vanishing lines converge at the facade, but the framing is not quite "right."

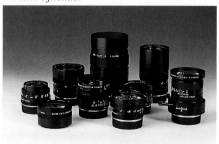

Focal length 180mm, distance 10.5 feet (3.2 m)

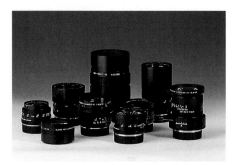

Focal length 100mm, distance 5 feet (1.5 m)

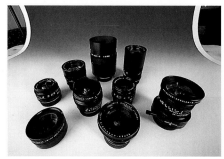

Focal length 15mm, distance 1 foot (0.3 m)

wide-angle lens from a short distance and from a higher angle. The lenses, particularly those in the foreground, now appear grossly distorted, with elliptical front elements and filter threads. Their barrels are tapered toward the bottom, so they appear almost conical.

Likewise, the 180mm and 100mm shots of the colored pencils on page 79 also look natural. The edges of the packs are nearly parallel, with only a trace of converging lines. This perspective seems realistic, if uninteresting. The effects of perspective distortion are also obvious in the photos of the pencil boxes. At such a short distance, the pencil points are substantially nearer to the film plane than are the packs. So the points look much larger than the bottom of the boxes, and steep vanishing lines are visible.

A comparison of each set of photos is revealing. In the wide-angle image of the lenses, distortion of perspective is so extreme that the photograph can only serve as a caricature. We all know what a lens looks like, and the 15mm photo, while recognizable, isn't quite right. The telephoto shots do

not display any noticeable sense of perspective, so they seem far more "normal" and are generally preferable. (This might not be true for "flat-looking" photographs taken with a powerful telephoto lens from a long distance.)

The telephoto shot of the pencil boxes is also correct in appearance, yet perhaps a bit dull. By comparison, the wide-angle shot creates a more dynamic impression. The short focusing distance and high angle cause an exaggerated depiction of perspective slightly stretching, but not disfiguring, the packages and pencils. The photo is rather lively and creates a sense of connection to the subjects.

These examples clearly indicate that there are no mandatory rules for making use of perspective, even in industrial photography. The aim is to achieve a visual effect that suits your concept of the image. Camera position and lens focal length should be chosen to create the desired perspective, not merely to crop out distracting details. If necessary, you can crop a negative or a chrome, but perspective can only be created at the moment of exposure.

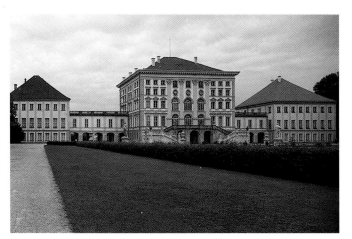

The use of a shift lens improved the framing of the scene. The lens was shifted to the right, producing a combination of a frontal and side view.

Here is a frontal view taken without a shift lens. The sides of the main building are not visible. It offers a feeling of perspective, but no dimension.

Perspective Control with a PC Lens

Imagine that you are photographing a building at an angle so the front and a side are both visible. Even if you align the camera vertically, you can't align it horizontally with either surface. Therefore, according to the rules of central projection, horizontal converging lines will be visible. Of course, you can avoid this problem (if it is one) by photographing the building from the front and carefully aligning the camera in both directions. But this creates a static, flat impression and loses the sense of depth provided by showing the building's side.

Fortunately, there is a way to include more than one surface and still maintain proper perspective. To achieve this "parallel" perspective, you have to shift the lens' optical axis, which is easily accomplished with the swings and tilts of a large-format view camera. The 35mm photographer can achieve similar effects, within certain limits, by employing a perspective-control "shift" lens.

To achieve parallel perspective, you first align the film plane with the front surface, then shift the lens axis to include the second surface. The series of shots showing the Nymphenburger Chateau offers a good example; the first three were taken from precisely the same position with a 28mm shift lens.

In the first photo, central projection caused the front and side to be depicted with distinct vanishing lines. For the second shot, the film plane was aligned parallel to the facade, correcting the perspective lines but creating a woefully inadequate composition. With the film plane still aligned parallel to the front of the building, the lens is shifted 11 mm to the right for the third picture. The composition is vastly improved, while correcting the perspective lines. Therefore, the facade is presented in a natural-looking way. (The fourth picture, shown for comparison, was taken straight-on from the front of the chateau.)

Parallel perspective is not just helpful for outdoor shots. For studio photographs of rectangular objects such as packages, books, or appliances, it creates a desirable, natural look. The effect renders a three-dimensional object just as we

Focal length 15mm, distance 0.8 foot (0.25 m)

Focal length 100mm, distance 4 feet (1.2 m)

Focal length 180mm, distance 9 feet (2.8 m)

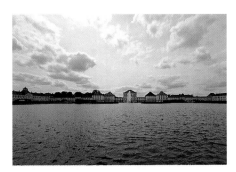

An undistorted photo of a chateau with the film plane aligned vertically.

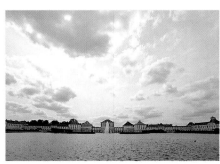

A distorted perspective of the chateau caused by tilting the film plane upwards.

A distorted perspective of the chateau caused by tilting the film plane downwards.

Both of these photographs were taken from the same location with a 15mm lens. In the upper photo, the building is undistorted due to its being aligned parallel to the film plane. But even a slight adjustment of the camera's angle will distort the building's perspective.

perceive it, on a two-dimensional surface. Parallel perspective is also vital for picturing technical products in a way that reveals their construction details and spatial proportions.

Composition

The photos of the lenses and colored pencils simply demonstrate the effects of different focal lengths and shooting positions. They are not meant to be examples of ideal composition or point of view. In fact, it would be futile to picture a scene with different focal lengths and from changing positions, simply hoping that one of the shots will capture the right perspective.

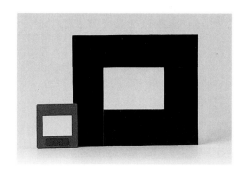

A format mask is a valuable tool for image composition. It can be set for any film format. If you are shooting 35mm slides, set the format mask so that it frames an area double that of the slide mount. This dimension will help you visualize how the picture will be framed.

Previsualizing a photograph is much more direct.

Even before unpacking or setting up your camera, the scene can be viewed through a "format mask" to help determine the picture-taking position, focal length, and perhaps also the film plane alignment. This format mask (or viewing frame) can be made of black cardboard or an empty black slide mount. As mentioned before, you should first determine the picture-taking position and camera-to-subject distance, then choose a focal length that provides the desired cropping. With a mask the same size as the film format, the distance it is held from the eye is equal to the lens focal length. This rule holds true for distant subjects only; when shooting at close range, the eye-to-mask distance must be extended by a factor of 1.5x or 2x.

For 35mm photography, however, use a cardboard mask with inside dimensions of 48x72 millimeters, just twice the size of the film format. This is far more comfortable than using a 35mm slide frame, which would require uncomfortably close face-to-mask distances when framing for wide-angle lenses. Viewing the image area through a 48x72 mm opening enlarges the image area fourfold,

Select a focal length that will produce the desired perspective...
(100mm focal length)

...and allow the intended image area to fill the frame.
(21mm focal length)

while doubling the viewing distance.

With a 100mm lens and a subject at infinity, the distance between eye and mask is about eight inches (20 cm). At close range, the lens extension is longer, so you have to hold the mask at a greater distance. For a focusing distance of about six feet (2 m), with the same 100mm lens, the mask-to-face distance is 10 inches (25 cm); at three feet (1 m), it's about 12 inches (30 cm). In practice, the mask will be used mostly at medium and long distances, so don't worry about stretching your arm for close-ups.

Using a format mask can help you find the best picture-taking position and focal length quickly and accurately. By tilting the mask, the necessary alignment of the image plane can also be determined. However, this requires a bit of experience to overcome the eye's tendency to compensate for perspective lines.

Some photographers may find this approach quaint in an era of fully automatic, high-tech cameras. On the other hand, this method allows the best perspective to be determined more quickly than by repeatedly changing lenses. Of course, a format mask is not suited for zoom-and-snap picture-takers, such as photojournalists or sports photographers. This technique is very measured and is aimed at the methodical photographer who carefully crafts each exposure.

Viewing the scene through a format mask quickly trains your eye to judge the "look" of a potential image. The frame will easily fit into any bag and allows you to visualize scenes even without a camera. That way, you can keep exploring the effects of perspective and focal length in determining the final appearance of your photographs.

Perspective and the relationship between dimensions can both be altered by changing the camera's taking position. All three photos were shot with the same focal length and from a nearly identical distance.

Use a format mask in your quest for subjects. The overall view in the horizontal shot tends to be dull, while the vertical-format shots taken from different positions and with various focal lengths display more interesting points of view. Those who use the format mask will often be rewarded with more appealing compositions.

Definition and Depth of Field

As you know, the main function of the lens aperture is to control the amount of light passing through to the film. The aperture influences two additional, vital functions—image resolution and depth of field. A bit of theoretical knowledge is helpful in understanding how these variables operate.

When maximum definition and contrast is required, use depth of field to your benefit and select an appropriate aperture. To shoot a close-up subject such as the flower above, maximize the range of sharp focus by setting a small aperture. A larger aperture was used to capture the photo below, where the plane of focus is narrower.

Diffraction and Critical Aperture

In theory, a perfect lens would offer its greatest resolving power at its maximum aperture, with the diaphragm wide open. As the aperture gets smaller, there is an inevitable increase in diffraction or bending of incoming light rays at the edges of the diaphragm blades. This prevents the rays from traveling on in a straight line and leads to points on the subject being reproduced as small disks. As the size of the diaphragm opening decreases, the diameter of these disks increases, progressively reducing the potential resolution of the image.

Diffraction is influenced not only by the aperture, but also by the color (wavelength) of light and by the reproduction ratio. Unfortunately, diffraction gets stronger in close-ups, just when you need a small aperture to increase depth of field.

In the imperfect world of real lenses, diffraction is not the only factor limiting image quality. Most optical aberrations are at their worst with the diaphragm wide open and improve markedly if you close down by two or three stops. By doing so, you remove the light rays coming in from the edges of the lens, which cause the most

trouble. So, in practice, you need to find the aperture that offers the best control of image defects, without creating too much diffraction.

This desirable *f*-stop, termed the "critical" aperture, differs from lens to lens. As a general rule, it can be achieved by closing down two to three stops. But at close range, you may have to stop down even further to obtain sufficient depth of field, at the cost of lowered resolution.

Depth of Field and Circle of Confusion

Most photographic subjects are three-dimensional, therefore different parts of the subject are at different distances from the two-dimensional image plane. (An exception is copy work involving a flat subject.) According to the laws of optics, only one object plane can ever be depicted as truly sharp in the image plane. However, thanks to the optical illusion called depth of field, zones behind and in front of the object plane also appear more or less sharp.

Actually, every point of the pictured object is reproduced not as a point but as a disk, called a "circle of confusion." These disks look sharp to us, as long as they remain

smaller than the eye can resolve. Human resolving power changes with the viewing distance, which in turn depends on the size of the image.

Object points in critical focus are at a minimum size or "circle of least confusion." The largest circle that is still seen as a point at a specified distance is the permissible circle of confusion. Depth of field is the distance between the nearest object point rendered as a permissible circle of confusion and the farthest object point rendered as a permissible circle of confusion.

As a convention, the diameter of the permissible circle of confusion is considered to be 1/500 the size of the film format diagonal. Therefore, the circle of confusion is 0.03 mm for the 35mm format, 0.06 mm for 2-1/4-inch square (6x6 cm) medium format, and 0.2 mm for the 8x10-inch large format. In enlargements, the permissible circle of confusion diameter increases along with the magnification factor, so you don't lose depth as the print size increases. This is based on the reasonable expectation that larger prints will be viewed from greater distances.

Depth of field does vary with the on-film reproduction ratio, so you have less depth for close-up subjects. The distribution of sharpness is also affected by the focusing distance. For subjects from infinity to about twenty times the focal length in use (about three feet for a 50mm lens), 1/3 of the depth of field is in front of the focusing plane and 2/3 behind the plane. At shorter distances, depth of field is distributed evenly, in front of and behind the focusing plane. And for close-ups with reproduction ratios greater than 1:1 (full life-size), 2/3 of the depth of field is in front of, and 1/3 behind, the focusing plane.

The greatest possible depth of field can be achieved by setting your lens to the "hyperfocal" distance. To achieve this, place the focusing ring so that the far depth-of-field indicator for the chosen *f*-stop is at the infinity mark. Distant subjects may not look sharp in the viewfinder, but they will be fine in the actual image.

Hyperfocal Distance

Hyperfocal distance is very important for 35mm and medium-format cameras, because they do not generally provide the depth-enhancing movements of large-format models. Hyperfocal distance can be calculated mathematically using the focal length, the aperture, and the admissible circle of confusion. During everyday photography there is hardly time for such computation, which can't be transferred to the lens with this degree of accuracy anyway. A more practical method is to set the infinity mark on the focusing ring to the far end of the available depth of field, as indicated on the depth-of-field scale for the chosen aperture.

With a 50mm lens at an aperture of *f*/16, place the infinity symbol to the number 16 on the far side of the depth-of-field scale. Depth of field will extend from there to the distance indicated by the other number 16, located on the near side of the scale. In this example, if you set the focusing distance to infinity, the depth of field stretches from 15.39 feet to infinity. More to the point, if you set the focus to 15.39 feet, the zone of sharpness extends from *half* this distance (7.69 feet/2.34 m) to infinity. That's the most depth you can possibly achieve with a 50mm lens at *f*/16.

The hyperfocal distance is well

The shallow depth of field clearly differentiates the main subject from the background.

Depth of field is greatly reduced within the macro range. In this photo, taken at a reproduction ratio of 1:1, the focusing plane was placed on the fly's eyes. At f/8 and with a reproduction ratio of 1:1, the depth of field has a range of only 1 mm.

suited for candid photography, because it allows you to shoot without focusing. It also enables you to achieve optimum depth of field for near/far compositions, such as landscapes. Just be sure the resulting shutter speed is fast enough to freeze camera shake and subject motion.

Other Factors That Affect Depth of Field

In addition to the aperture opening and the circle of confusion, depth of field is also affected by the focal length and the focusing distance. Here are the rules:

— If the focusing distance and focal length remain the same, smaller apertures give greater depth of field.

— If the focusing distance and aperture remain the same, depth of field diminishes with increasing focal lengths (with the square of the focal length, to be precise).

— For any given focal length, depth of field increases in direct proportion to the focusing distance.

— At a given reproduction ratio and aperture, every focal length produces the same depth of field (although each may require a different focusing distance). In practice, the effects of focal length and focusing distance tend to cancel each other out.

The only exception to the last rule is for lenses of the same focal length used on different film formats. For example, a 90mm lens for the 35mm format offers half the depth of field of a 90mm normal lens for the 6x7 cm format, because the latter format allows a circle of confusion about twice as wide. To achieve equivalent depth of field, the 90mm telephoto lens has to be closed down two stops more than the 90mm normal lens.

Perspective is determined by the camera's position in relation to the subject, not the focal length of the lens used. This picture demonstrates how the foreground can be greatly exaggerated by getting in close with an ultra wide-angle 21mm lens.

Focusing

Most of today's 35mm SLR systems offer both autofocus and manual focus. But how do you know which to use? This chapter will help clarify the benefits and appropriate uses of each, as well as discussing the accessories that make focusing easier in a variety of challenging situations.

The function of a lens is to project an image of the object plane (your subject) onto the image plane. Proper focusing makes sure that this image plane coincides with the film plane of the camera so you get a sharp photograph. During focusing, the lens or individual lens elements are shifted along the optical axis until the image and film planes are congruent. Whether this process is done automatically or manually, the principles remain the same.

Autofocus Systems

Autofocus systems can be divided into passive and active types. The distinction is simple: Passive AF depends on existing light reflected from the subject; active AF systems emit infrared rays, which bounce off the subject and return to the camera. In either case, the reflected rays are received by a photosensitive element and analyzed by the camera's AF computer. In general, 35mm SLRs use passive AF systems, while point–and–shoot cameras use active autofocus.

A variation on the AF theme is the triangulation system, which calculates the focusing distance based on the angle of the returning rays. Also, some Polaroid instant cameras are equipped with a Sonar AF system that sends out ultrasonic pulses, then "listens" to the echo to determine distance.

Whatever its sensing method, each AF system conveys the focusing information to a dedicated motor that sets the proper distance on the lens. In 35mm SLRs, the AF motor may be built into the camera body or integrated in each lens. Where the AF motor is located is dependent on the equipment manufacturer. There are pros and cons to both designs.

This is certainly an incomplete classification of autofocus systems, disregarding the many individual variations and solutions used by the different camera manufacturers. A detailed description of all existing AF systems is not necessary, however, for our purposes. What is vital for accurate focusing is to be aware of the capabilities and limitations of these systems.

The Limitations of Autofocus

Because the passive AF system reacts to an object's reflections, problems can arise with low-contrast,

Predictive autofocus:
Capturing high-speed motion is the specialty of autofocus. However this scene could also have been frozen with an appropriately fast shutter speed and an aperture suitable for producing the necessary depth of field.

Here the main subject is in the center of the frame, but there is no structure that is readily recognizable to an autofocus system. Such a subject would confuse the autofocus sensors and would be best shot using manual focus.

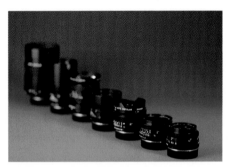
f/2.8

f/4

f/5.6

f/8

f/11

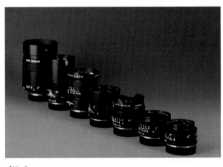
f/16

The depth of field increases when the aperture is closed one stop at a time. These shots were taken with the Leica Apo-Macro-Elmarit-R 100mm f/2.8 at a distance of 5 feet (1.5 m) and focused on the closest lens.

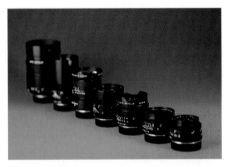
f/2.8

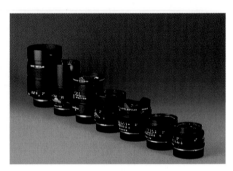
f/4

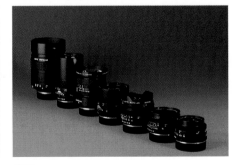
f/5.6

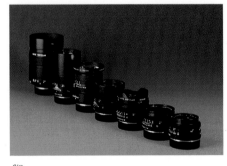
f/8

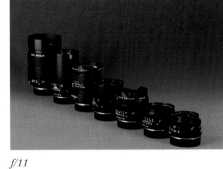
f/11

f/16

These photos were taken using the same parameters as the photos above, however focus was placed on the third lens. Notice how sharpness is maximized by focusing one-third of the way into the scene.

very bright, or very dark subjects. High-performance, new-generation AF cameras enable automatic focusing even at dawn or in candlelight, with light levels as low as EV −1. Such values are stated for an aperture of f/1.4 (and ISO 100 film), so the corresponding level will be higher when a slower zoom lens is used. At shorter distances an AF illuminator, built into the camera or the flash unit, may allow focusing even in total darkness. In effect, this transforms passive AF into an active system.

AF sensors can be baffled by highly polished surfaces, backlight, strong reflections in water, or brilliant highlights. Smooth, patternless surfaces, with no effective contrast, are also very difficult for an AF system to handle. Similarly, objects with very small, repeating patterns can present multiple "targets," each of which is smaller than the AF sensor can resolve. This situation sometimes occurs in wide-angle shots taken from great distances. Depending on the subject and situation, either focus manually or take an AF reading of another object at the same distance, lock focus, recompose, and shoot. On most models, the AF lock is activated either by pushing a designated button or by exerting light pressure on the camera's shutter release button.

Most AF sensors can only focus on features at right angles to their own alignment. Therefore, a horizontally arranged sensor will be able to focus on vertical structures, but not horizontal ones. Early AF cameras only had sensors arranged in one direction. If the camera couldn't find focus, photographers had to rotate the camera so prominent subject lines were perpendicular to the AF sensor, autofocus, lock the distance setting, then return the camera to the desired composition.

This was a valid criticism of the first autofocus systems.

Now most current AF systems have sensors in both directions and can detect both vertical and horizontal structures. However, more sensors, for instance two arranged crosswise, require a considerably larger AF-measuring area. Parts of the scene other than the main subject may therefore be registered, including overhanging branches or a fence in the foreground.

Objects situated in front of the main subject, such as cage bars or window frames, can also lead to incorrect distance measurements. Make sure the AF sensor is pointed *between* the bars, so it can read the actual subject. Repeating patterns of evenly distributed structures, such as fences or window blinds, may also be problematic for the autofocus system.

Finally, pay special attention when using filters or other attachments. Linear (rather than circular) polarizers are famous for interfering with AF sensors; neutral-density, graduated neutral-density, soft-focus, or special-effect filters may cause problems as well.

Manual Focus

Like autofocus, manual focus is achieved by changing the spacing between the lens elements and the film. However, instead of a motor, it is the photographer turning a focusing ring to work the helical threads and move the elements gradually and precisely. The focusing mechanism must be calibrated exactly to correspond with the distance scale on the lens barrel.

Focusing manually is sometimes advantageous even with autofocus cameras. Situations where manual focus may be more effective

Studio shots taken using a tripod are usually focused manually as autofocus does not suit a still-life photographer's method of working. But this type of work is not what AF systems are conceived for anyway. Several professional photographers are known to switch off the autofocus system and focus manually even for fashion, portrait, and nude photography.

In some situations, a right-angle finder can provide more comfort for composition and focusing.

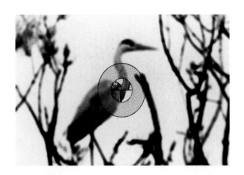

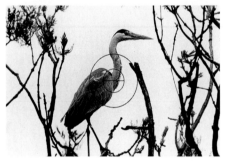

Standard viewfinder screens that most cameras are supplied with offer three focusing aids: a split-image rangefinder, a ring-shaped microprism, and an overall-matte field.

A matte screen with an etched grid

An overall-matte screen

include very dark subjects, low-contrast subjects, shiny subjects (with reflective surfaces), strongly backlit subjects, or scenes on the other side of a fence or window.

The universal manual focusing aid found in most SLR cameras is the viewfinder's focusing screen, plus an electronic rangefinder is available on most autofocus cameras. Using the focusing screen is very straightforward. Look through the viewfinder and rotate the focusing ring until the subject appears to be clear and sharp in the viewfinder. Manual focusing with the focusing screen is easiest in strong light. Use the matte section of the focusing screen in unfavorable conditions. If this is new to you, practice first in strong light, then gradually test yourself in less and less light. If your camera has an electronic rangefinder, you can use it to test your results.

The electronic rangefinder is located in the camera's viewfinder. It is commonly a dot that illuminates when the object in the focusing sensor is in focus. Some electronic rangefinders also have arrows that show which way to turn the lens to achieve focus.

To use the rangefinder, check that both the camera's focus mode selector and the lens' Autofocus/Manual switch (if there is one) are on Manual. Now look through the viewfinder and position the focus brackets on the subject. Lightly depress the shutter release button to activate the camera's electronics. Turn the lens focusing ring. When sharp focus has been achieved, the focus-confirmation dot appears.

If you are focusing manually because the subject was problematic for autofocus, the electronic rangefinder will also have difficulty. Also, some lenses are not

compatible with electronic rangefinder functions. Examples of these lenses include: PC (perspective-control) lenses, catadioptric (mirror) lenses, and lenses with small maximum apertures.

Focusing Accessories

Various shooting circumstances often call for different focusing aids. For the best possible focusing in any shooting situation, you may need viewfinder accessories such as an adjustable-diopter eyepiece, a right-angle finder, an eyecup, and interchangeable focusing screens. These are readily available for many 35mm SLR cameras.

In manual-focusing (MF) SLRs, a bright, contrasty viewfinder image is vital for accurate distance setting. This requires a finder with good optical quality in the pentaprism, eyepiece lens, and all other components. Fast lenses also contribute greatly to the viewfinder's brightness.

Beyond contrast and brilliance, the viewfinder should help photographers compensate for their own visual defects. To achieve this, some cameras have an integrated diopter-adjustment device, enabling the viewfinder eyepiece to be matched individually and precisely to the photographer's vision. Even cameras that don't provide this valuable feature usually allow diopter-correction lenses to be attached to the eyepiece. These lenses are also used when the integrated diopter-adjustment feature does not provide sufficient power for the required correction.

The significance of eyesight correction should not be underestimated. To set the distance precisely, the photographer must be able to see the viewfinder image

sharply. After all, even the best lens is not worth much if it is not focused accurately.

An eyecup is often fitted onto the viewfinder eyepiece to protect it from intense sidelight, which makes focusing difficult (and may produce inaccurate meter readings as well). Many photographers also use eyecups to prevent their glasses from being scratched. However, eyecups may cause slight vignetting of the viewfinder image, particularly for eyeglass wearers, making it difficult to see the corners of the image and/or the data displays.

Right-angle finder attachments are welcome for focusing at ground level, over the heads of a crowd, or even around the corner of a building. These devices are also useful for macro and copy work. Usually, the accessory mounts on the camera's eyepiece and can be rotated a full 360°, with click-stop positions every 90°.

High-quality right-angle attachments generally offer two settings. The normal position shows the entire viewfinder image, including the information display. When switched to the "2x" position, only the center of the image is shown, doubled in size to make focusing easier. But you have to switch back to the normal setting to view the image that will be captured on film.

Some right-angle attachments are even equipped with integrated diopter adjustments. The optics should be calibrated so the markings in the center of the focusing screen can be seen sharply, whether or not the lens is in focus.

Focusing Screens

High-grade focusing screens demand a lot of manufacturing expense to achieve their excellent optical quality. In addition to the standard-type screen, many SLR models allow specialized screens to be fitted, either by the photographer or at a service center. Naturally, this feature is most appropriate for SLRs that appeal to serious photographers.

Depending on the subject, reproduction ratio, focal length, and lighting conditions, various types of screens can make focusing easier. However, for best results you need to know the advantages and drawbacks of different screens. We will therefore discuss the most important types and their respective applications.

Standard Screen

Most MF cameras are supplied with a "universal" focusing screen, well-suited for most common situations. Often, a split-image rangefinder 3 mm or 4 mm in diameter is located in the center of these standard screens. A microprism ring surrounds the split-image center (or it may take the place of the rangefinder). The balance of the image area looks like a classic, matte ground glass, but usually consists of tiny, finely ground microprisms.

The split-image rangefinder allows even inexperienced photographers to focus quickly and accurately on subjects with distinct edges or patterns. When the two halves of the split image come together, the chosen section of the subject is in focus. Conversely, the microprism ring enables focusing on surfaces and structures without recognizable lines or contours. If the image is unsharp, the microprism ring shimmers; the effect disappears when the subject is brought into focus.

Both focusing aids may fail in low light, particularly with telephoto lenses of 180mm or longer,

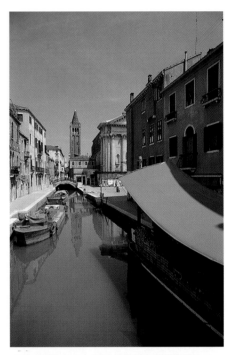

An overall-matte screen can be useful when composing and focusing ultra wide-angle shots that display much detail.

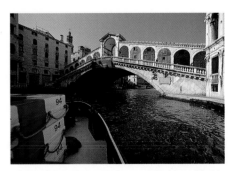

The Rialto Bridge was photographed hand-held using a 15mm lens from a moving Vaporetto. With an angle of coverage of 110°, it would have been nearly impossible to have aligned the camera accurately without the help of a focusing screen etched with a grid.

A focusing screen with a grid was invaluable to achieving accurate camera alignment and image composition.

Even when the hyperfocal distance is set, only one image plane will be truly sharp. The only difference between these two photos is that the focusing distance in the photo below was closer to the camera.

and/or maximum apertures of *f/4* or slower. When this happens, the split image darkens, rendering focusing impossible, and the microprisms become indistinct. Of course, you can still use the surrounding matte field for focusing in the traditional way.

Microprism Screen

The microprism focusing screen, as mentioned earlier, is standard on some SLRs. It has no split-image rangefinder, only a central microprism spot surrounded by a matte field of fine-ground prisms. Focusing is done on the microprism spot or on the surrounding matte area.

Whenever the central subject area is out of focus, the microprisms produce a shimmering effect. Once the area is focused accurately, the shimmering ends and the subject becomes fully visible. The complete image can then be viewed, undisturbed by any noticeable focusing aids.

The transition from out of focus to sharp focus is not as apparent with a microprism spot as with a split-image rangefinder. In low light or with the long lens extensions employed for macro photography, precise microprism focusing becomes very difficult. Like a rangefinder, the microprism spot can darken with slow lenses, especially at focal lengths of 180mm or greater.

Overall-Matte Screen

The complete surface of a matte screen is fine-ground, with perhaps a central reference circle for the selective exposure-metering mode. At all times, the entire subject area

can be viewed without interference. Focusing is done by sight, which calls for some experience, since the transition from unsharp to sharp is gradual rather than sudden.

A totally matte screen delivers a very bright viewfinder image, and the circle in the center will not darken, so focusing is quite comfortable even with slower lenses. Additionally, this type of screen is well suited for focusing telephoto and macro lenses.

Matte Screen with Grid

Some manufacturers also offer an overall-matte screen inscribed with a grid of vertical and horizontal lines, dividing the image area. As in the previous type, there is a central reference circle, perhaps with the addition of a cross-hair reticle. In close-up and macro shots, the reproduction ratio can be ascertained directly from the screen, because the reference marks are situated at exactly defined intervals.

The gridded, overall-matte screen offers a brilliant viewfinder image, up to two stops brighter than a standard screen. This serves well when focusing slow telephoto lenses or focusing in low light. And the grid is particularly useful in aligning the camera precisely for architecture, panorama, or copy work. This allows converging lines to be avoided and helps to align the horizon correctly in the upper or lower third of the format.

For some, the gridded-matte screen allows very comfortable focusing with most lenses and any type of subject. Other photographers prefer a plain overall-matte or microprism screen, because they dislike having any marks in the viewfinder.

Shutter Speed and Sharpness

In recent years, the correlation between image sharpness and shutter speed has become a bit murky, due to the proliferation of ingenious autoexposure modes. Yet the basic rule is unchanged: Even the best lens won't make sharp pictures if you shoot at the wrong shutter speed.

Sharpness is still the most important technical criterion for many photographers, rated higher than proper exposure or even composition. Lack of definition, on the other hand, is the most common cause of disappointing pictures, despite all advances in autofocusing and lens design. Of course, some photographers deliberately create blurry images, with varying degrees of artistic success. For our purposes, however, we will assume you want pictures that are as sharp as possible.

The main reason for fuzzy pictures is inadvertent camera movement while you are releasing the shutter and during the actual exposure. Contributing factors include lenses and (occasionally) films of mediocre quality, imprecise focusing, and inadequate film flatness. But these secondary flaws are only worth investigating if you are *sure* the camera is being held steady.

What follows is an exploration of the connections between shutter speed and image definition. It applies to every type of camera and lens, whether AF or manual-focus, fixed focal length or zoom.

Shutter Speed and Subject Motion

Your choice of shutter speed controls the rendition of both subject and camera movement. These motions can either be frozen or blurred by selecting a fast or slow setting, respectively.

Moving subjects cause an obvious reduction of image sharpness if the shutter speed is not high enough to stop the motion. Greater subject magnification and (of course) slower shutter speeds tend to increase this subject-blur effect. And the direction of the movement is just as important as its velocity.

To find an appropriate shutter speed, you can either use tedious equations or remember a few practical rules. We prefer the latter. For example, to freeze the motion of an average pedestrian at a distance of 15 feet (about 5 m), the minimum requirements are:

—1/500 second if the subject is moving at a right angle to the shooting direction.
—1/250 second if the subject is moving on a diagonal.
—1/125 if the subject is moving toward or away from the camera.

An exposure of 2 seconds makes the water seem to flow and gives the waterfall a "velvety" appearance.

The turbulent water was frozen in motion by using a short shutter speed of 1/1000 second.

A slow shutter speed was used intentionally to photograph this bicyclist, separating him from the background and adding a sense of speed to the image.

Use as fast a shutter speed as possible when shooting hand-held with a moderate telephoto lens to avoid recording a blurred image.

A sturdy professional tripod and a camera's mirror lock-up feature are of great assistance when shooting with long telephoto lenses.

For a subject traveling twice as fast, at the same distance, double the required shutter speed. Closer subjects need even higher speeds, while distant ones can get by with slower speeds. Naturally, if you want to create a motion-blur effect, a significantly slower speed is required. In our example, try a setting between 1/15 and 1/4 second. Much higher, and the slight blur may seem like an accident; much lower, and the subject may be totally unrecognizable. To ensure that the background remains sharp, a tripod is mandatory.

Conversely, you may desire a sharp subject against a blurry background. This can be achieved by panning the camera in the same direction as the subject's motion during exposure. Again, the shutter speed should be slow enough so as not to freeze the action but not so slow that everything turns to mush.

The photographer Ernst Haas created wonderful pictures by purposely rendering parts of the image unsharp. More recently, it has become quite fashionable to use lack of definition as a means of style.

Camera Shake

Holding the camera absolutely steady during exposure is difficult, and not just for beginners. Image blur is often caused by a restless photographer releasing the shutter with a jerk. The camera may cause vibrations as well, initiated by the action of the mirror, the shutter, or even the lens diaphragm.

Camera shake typically causes overall blurring, perhaps with ghosting or multiple outlines of subjects. Unlike a picture with subject-motion or selective depth of field, *nothing* in a shaken image is clear. But like subject motion, camera shake increases at longer focal lengths (greater subject magnification) and at slower shutter speeds.

A common rule of thumb suggests using the reciprocal of the lens focal length as the slowest shutter speed for handholding a camera. With a 50mm lens, the minimum is 1/60 second, and for 200mm, it's 1/250 second. Yet even this venerable approach does not always guarantee unshaken pictures, even for experienced photographers. Anyone wishing to preserve the full image quality of a fine lens should probably double or even quadruple these shutter speeds, if circumstances allow.

Mounting your camera on a sturdy professional tripod is the safest way to avoid camera-motion blur (although it does not affect subject motion). If time and camera design permit, release the mirror before each exposure. Often, the mirror lock-up function operates mechanically, preventing electro-mechanical triggering of the shutter with the self-timer, electronic remote-release cords, or the motor drive's release button. When the mirror is to be locked up, most cameras must be operated in the manual exposure mode, since metering cannot be done with the mirror up.

If your camera has no mirror lock-up feature, the self-timer may achieve a similar effect. Also, keep in mind that mirror vibrations are most noticeable in images taken at shutter speeds between 1/2 and 1/15 second. At higher speeds, they don't have much chance to cause trouble. And on a stable tripod, the vibrations gradually subside at still slower speeds, so the adverse effects are less obvious.

Lens Accessories

Accessories can expand the versatility of your lenses, letting you explore new applications such as the macro range. Filters, close-up lenses, and other attachments can also extend your creative horizons.

Filters

Filters are part of an advanced photographer's basic equipment. They can alter reality, enhance a picture's appearance, or turn an average subject into a photo bursting with excitement. Conversely, filters can ensure true-to-life tonal values and accurate color rendition. Each application has its own class of filters, including black-and-white, color, special-effect, and technical types. The most important filters and their respective applications are described below.

But before deciding on any specific filter, a few basic aspects should be considered. Filters are made of tinted glass or plastic. Depending on the lens, they mount on the front of the lens, drop into a drawer, or are built into a turret in the lens.

Filters are accessories that do not belong to the original optical design of a lens, but when mounted they become part of it. To preserve the abilities of your lenses, filter quality should always be a prime consideration.

The best optical performance is provided by filters made of solid glass, tinted throughout, precision-ground to absolute flatness, and coated with one or more anti-reflective layers. The coating should be matched to the particular filter type, just as it is with lenses. Finally, the filter should be mounted properly in its frame, so no physical strain will disturb its flat, parallel positioning.

As you might expect, brand-name, high-grade filters are not exactly cheap. To economize, many photographers buy filters big enough to fit their largest diameter lenses and use adapter rings to fit the filters to smaller lenses. While this is certainly better than using small filters on large lenses, it is still not a great solution. In most cases, you won't be able to attach or pull out the lens shade with the large filter in place. Using a lens shade with filters is paramount, because filters add extra glass-to-air surfaces, with the potential for added reflections. In addition, the adapter rings may cause vignetting with ultra wide-angle lenses.

Filter holders represent a reasonable alternative, allowing plastic or gelatin filters to be used on almost any lens. Many popular filter systems, such as those manufactured by Kodak and Cokin, offer great versatility. And plastic and gelatin filters can also

A slight increase in contrast can be achieved by using an orange filter when shooting with black-and-white film.

A 21mm lens gives this photo a sense of space, while a red filter is responsible for producing an increase in contrast in order to achieve the right mood.

A graduated filter can be used to balance extreme differences in brightness within a scene. In this photo, the filter prevented the foreground from being underexposed and the sky from being overexposed.

One of the classic uses of polarizing filters is to minimize reflections on the water's surface.

be employed in bellows-type lens shades. Although more economical and versatile then glass filters, plastic and gelatin filters are very sensitive to scratches, and they tend to attract dust.

To create the intended effect, filters block some of the light passing through to the lens. They also present extra air-to-glass surfaces and, depending on their optical quality, they may refract light more or less strongly. The inevitable result is a loss of brightness, sometimes accompanied by a reduction of sharpness and contrast.

The degree of light loss for each filter type is specified by the manufacturer as a compensation or filter factor. TTL metering systems in SLR cameras generally compensate for this filter factor automatically. When working with a hand-held exposure meter, you must adjust the measured value manually, using the compensation factor. Alternately, you can hold the filter in front of the exposure meter, so the light loss will be included in the measurement. This method is not recommended, however, for graduated or special-effect filters. Their compensation is affected by their position, which is difficult to reproduce exactly.

The filter factor also depends on the color temperature of the ambient light. In most cases, the nominal factor is based on noon daylight (5500° Kelvin), and will not be exactly correct early in the morning, at dusk, with an overcast sky, at high altitudes, or in artificial light. Depending on the color of the filter and the light's spectral composition, the factor may increase or decrease. To some extent, TTL metering systems adjust for these changes in color temperature. Even with TTL metering, you have to pay attention when

employing filters. The best approach is to concentrate on just a few filters, whose visual and exposure effects have been confirmed in test shots.

When several filters are used simultaneously, the individual exposure factors must be multiplied, rather than added together. As usual, however, there's an exception: Let's say you have already figured out the proper exposure using one filter. If you attach a second filter, add (rather than multiply) its compensation factor.

For black-and-white photography, color filters are used to alter the reproduction of color as darker or lighter shades of gray. Colors in the scene similar to the filter color are lightened and complementary colors appear darker gray than they would with no filter. The effects are particularly apparent with high-density, contrast-enhancing filters, such as orange and red, which darken skies and foliage.

These filters radically alter the spectral balance and may fool the camera's metering sensor. The same limitations apply to external metering systems. Although some manufacturers have attempted to reduce the problem by placing correction filters in front of the metering cells, totally consistent spectral response is not yet possible. Depending on the color of the filter and the color composition of both the subject and the ambient light, over- or underexposures may still occur. Furthermore, the fact that films are not equally sensitive to all visual wavelengths may lead to shifts in the rendition of tonal value and color. None of these caveats should prevent you from using and enjoying filters, but only provide guidance to explain any unexpected deviations.

Special accessories such as extension rings, close-up lenses, and bellows units allow you to photograph from short distances using conventional lenses.

Two or more filters can be used simultaneously, but should be chosen carefully. If you were to combine filters of contrasting colors, such as red and green, they would negate each other, producing a neutral-density effect. And it makes just as little sense to combine several filters of the same class, such as yellow and red models. The visual effect would simply be that of the stronger variant, red in this case.

You will probably find polarizers and graduated neutral-density filters to be quite useful; black-and-white photographers should also try red, yellow, orange, and light or dark green types. Despite the promises of advertisers, ever-increasing use of special-effect filters will not necessarily lead to greater creativity.

Finally, we'll talk about UV and skylight filters. The UV filter appears clear. Its purpose is to absorb ultraviolet radiation, which can reduce contrast and give color photos a blue cast. The skylight filter is a UV filter with a slight pink cast, which imparts a pleasant, but very subtle warming effect.

One of these filters is often kept mounted at all times to protect the front of the lens. There are two schools of thought on this. Some photographers feel filters should only be used when their optical effects are desired or in extreme environments, such as the desert, the open sea, or on river rapids. Others feel safer with the filter in place at all times. If the front of the lens is bumped against a hard surface, it is hoped that the filter will take the brunt of the damage. Photographers who want to be ready at a moment's notice often use a UV or skylight filter as a "transparent lens cap."

Macro Accessories

The close-up or macro range, with reproduction ratios from 1:10 to 10:1, is beyond the focusing capabilities of most lenses. Also, conventional lenses (except for macro models) are optically corrected for infinity, and give less impressive image quality at short distances. Special accessories such as close-up lenses, macro adapters, extension tubes, and bellows units furnish noticeably better close-up performance when used with appropriate lenses. These accessories can even be used with macro lenses to extend their scope.

High-grade close-up attachments like the Leica Elpros are well-corrected achromats consisting of two cemented elements.

This macro shot was taken with a conventional 90mm lens and extension tubes.

Close-Up Lenses

A close-up lens is used to alter the focal length of a camera lens, increasing the reproduction ratio without requiring a focusing extension. Such attachments are usually viewed as an economical alternative to a macro lens, for photographers who occasionally work in the close-up range. These screw-in accessories are hardly larger or heavier than a filter, and are sure to find a place in your camera bag, even when you're traveling light.

Quality close-up attachments are precision, two-element achromatic lenses, specifically designed for use in combination with particular focal lengths. Unlike single-element close-up lenses, achromatic attachments enhance the macro performance of a lens, if it is closed down by at least two stops.

The quality of achromatic lenses may even be appropriate for photographers who do a lot of macro work but want to pack light and work quickly. There is no need to deal with exposure compensation factors, which may be required with bellows units or extension tubes. Therefore, close-up attachments deliver a bright viewfinder image and allow spontaneous, hand-held shooting at close range.

For macro work, it's best to use a matte focusing screen, without a grid. All camera functions operate normally with close-up lenses, so you can use the exposure (and even AF) automation you paid for. Major manufacturers provide charts that show which lens attachment is suitable for each focal length, and the resulting range of reproduction ratios.

Extension Tubes

Extension tubes fit between the camera and the lens, increasing the focusing extension to achieve a larger reproduction ratio. Depending on your budget, extension tubes are available with fully automatic aperture and meter coupling, with auto aperture control and stop-down metering, or with fully manual operation.

Automatic extension tubes, also called macro adapters, are generally used in the aperture-priority

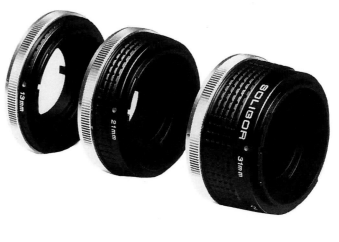

A set of extension tubes by Soligor for manual focus lenses

autoexposure and manual exposure modes. Shutter-priority and program autoexposure modes may be available, but they are not well suited for macro work (and may even cause exposure problems with some SLR models). The extension factor, caused by the increased distance between lens and body, is dealt with automatically by TTL exposure-metering systems. Readings taken with a hand-held meter have to be compensated manually, however, which can be a pain.

Extension devices with semiautomatic diaphragms are often supplied in three parts. One tube is attached to the camera and another to the back of the lens. When these two tubes are screwed together, they create an extension of about 25 mm. Adding the third tube between the other two gives you a total extension that is usually about 50 mm. With a 50mm lens, a reproduction ratio of 1:1 (life-size on film) is possible by adding the 50 mm extension.

Exposure metering is done via the stop-down method. With all three tubes in place, effective lens speed is reduced by two stops. So if the maximum aperture is $f/2.8$, the effective aperture for life-size reproduction is $f/5.6$. The viewfinder image becomes that much darker, making focusing more difficult. Once again, an overall-matte screen is helpful.

Your lens-aperture ring should be set to $f/8$ or $f/11$ for conventional lenses, which are corrected for infinity. (The addition of an achromatic close-up attachment may further improve optical quality.) Macro lenses perform well at slightly wider apertures, even with three extension tubes in place. Single tubes or combinations can be employed with focal lengths from 50mm to about 300mm.

One drawback of extension tubes is that they provide fixed, predetermined lengths. Combining tubes allows a bit more flexibility, but they are still not continuously variable. And if the tubes' threads are not aligned perfectly, the lens' aperture scale may not be exactly on top, making it mildly inconvenient to read.

Theoretically, several extension sets can be combined to achieve an even greater reproduction ratio. However, we don't recommend this practice. The image quality of lenses corrected for infinity deteriorates continually at increasing ratios, as both resolution and contrast diminish; meanwhile, shutter speeds become agonizingly long. You're better off heeding the focal-length and reproduction-ratio recommendations in the tables supplied by the manufacturers.

Bellows Units

Like an extension tube, a bellows unit mounts between the camera and the lens. Photographers who frequently shoot macro work need the flexibility of a bellows unit. With a maximum extension of about 125 mm, a bellows can achieve reproduction ratios up to 4:1, depending on the lens focal length. Lenses from 50mm to 300mm can be mounted. Bellows units are available with or without automatic diaphragms and autoexposure couplings. While you can fit a bellows to most autofocus SLRs, they still have to be focused manually.

Special lens "heads," without focusing mounts, are designed specifically to work with a bellows unit. These lenses offer macro focusing to 1:1 or greater, yet also can focus on subjects at infinity.

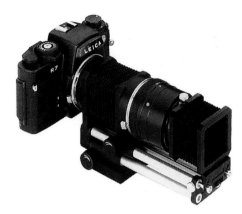

Automatic bellows unit for the Leica-R system with the bellows-type lens hood attached

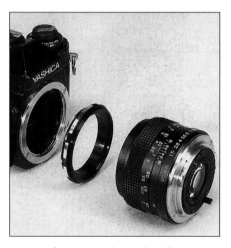

A reverse-focus ring is designed to allow conventional lenses to be attached with the front lens element facing the film.

Adapter rings make it possible to mount manual focus lenses on AF cameras.

Tamron's Adapt-All system allows you to mount their manual focus lenses on almost any current camera's bayonet lens mount.

An adapter ring from Hama is designed to allow the use of Canon FD, AE, and FL lenses on standard EOS bodies.

The latter is not possible with conventional lenses, because even when fully retracted, a bellows unit has an extension of about 1.5 inches (42 mm).

A well-designed bellows unit is sturdy enough to allow vibration-free photos and includes a locking device to prevent unwanted movement. There is usually a scale that indicates the bellows extension in millimeters, allowing you to duplicate any given setup. This scale also should display the reproduction ratios possible with common focal lengths, such as 50, 90, 100, and 135mm. Advanced bellows units let you rotate the camera carrier for convenient horizontal- to vertical-format changes.

When using a bellows, you first set the desired reproduction ratio on the calibrated scale. Then focus by shifting the entire bellows unit on its sliding base. (At moderate ratios, say 1:4 or less, the bellows extension can be varied for focusing as well as for setting the reproduction ratio.) Cameras with through-the-lens metering will automatically compensate for the amount of extension in use.

Reversing Rings

Many manufacturers also offer reversing rings. These let you mount a lens backwards, with the front element towards the camera body. The rationale is straightforward: Most lenses are corrected for infinity, where the span between the subject and the lens (called object distance) is much greater than the span between the lens and the film (image distance). But at a reproduction ratio of 1:1 (life-size), the two distances are equal. And when the subject is magnified beyond 1:1, the object distance

becomes smaller than the image distance. In other words, the lens is closer to the subject than it is to the film.

Theoretically, a lens in the retro-position can deliver very good image quality at reproduction ratios between 1:1 and 5:1. In practice, performance may be compromised by two factors: If the rear element, now facing the subject, is not well protected against stray light, contrast and sharpness will be reduced. Also, the lens-to-subject distances are so short you may have trouble providing adequate lighting.

Lens-Mount Adapters

Decades ago, most manufacturers provided SLR cameras and lenses with the ubiquitous M42 thread-mount, allowing easy switching between brands. For better or worse, those days are long gone. Now, some manufacturers cannot even guarantee compatibility within their own range of cameras and lenses, due to the introduction of computer-controlled electronics and advanced autofocus technology.

Nonetheless, some photographers still wish to attach older lenses to modern cameras. This is often possible, because the 42mm diameter thread mount is smaller than modern bayonet mounts. Several companies offer adapters to attach M42 lenses to modern SLRs.

For instance, when Minolta and Canon changed from manual focus to AF models, they introduced completely new lens mounts. Photographers in these divided "families" will appreciate the adapters that allow Minolta MD lenses to be attached to Minolta AF cameras, and Canon FD lenses to fit Canon EOS bodies.

Nikon and Pentax preserved their bayonet mounts, allowing manual focus lenses to mount directly on same-brand AF cameras, maintaining lens functions without any adapters.

With Tamron's Adapt-All system, any manual focus lens can be attached to most current MF and AF cameras, simply by changing the lens-mount adapter. Unfortunately, Tamron AF lenses do not share this feature.

Perhaps you've thought about attaching medium-format lenses to your 35mm camera. That's possible too with some camera systems. The advantage of such combinations is that only the well-corrected center of the image area is employed, which should result in very high definition and contrast. On the other hand, you have to deal with stop-down metering and manual diaphragm operation.

Along these lines, Pentax offers an adapter for their 6x7 lenses to be used on K-mount 35mm SLRs. Rollei has a similar device that serves as an interface between SL 66 lenses and 35mm Rolleiflex models. And Hasselblad lenses can be mounted on certain Nikon, Canon, and Contax/Yashica SLRs by means of Hasselblad or Kenko adapters. In addition, adapters are available for Exakta, Mamiya, Pentax, Rollei, Bronica and other medium-format lenses to be attached to various 35mm cameras.

Are lens adapters worth the effort? Consider that recent advances in lens-coating technology, new types of glass, aspherical elements, and computer-aided design all tend to give new lenses the edge in optical quality. However, some current lenses are designed and manufactured within extremely tight cost constraints, perhaps with less sturdy materials

than those employed years ago. So blanket claims for superiority of either newer or older lenses just cannot be valid.

It is certainly true that some adapters change the lens-to-film focal distance, which can reduce image quality. For example, when you attach M42 lenses to a Nikon SLR, the adapter must contain an optical element to compensate for the camera's greater focal distance (46.5mm from the mount to the film plane). This introduces two air-to-glass surfaces that were not included in the lens design, with a predictable reduction of definition and contrast. Similar problems arise with adapters that attach Minolta MD and Canon FD lenses to their respective AF models, because these cameras also have longer lens-to-film distances than their predecessors.

As you know, modern 35mm cameras offer many automated functions. Some are of questionable value, while others are truly useful, including the data display in the viewfinder, wide-open light metering, automatic diaphragm operation, and several autoexposure modes. With few exceptions, these conveniences are not available with a lens adapter in place. It's a bit strange to take a high-tech SLR and strip away all of its advanced features in order to attach an old lens. This approach is really only appropriate for exotic, rarely employed focal lengths.

Lens Shades

Most unwanted reflections in your photographs are actually multiple images of the lens-diaphragm opening, caused by a bright light source within the image area. Thanks to modern lens coatings,

Even with highly corrected and coated lenses, aperture spots cannot be prevented when light rays enter the lens at a certain angle.

Using a lens shade is always a good idea. It prevents stray light from entering the lens, which causes flare and reduces contrast.

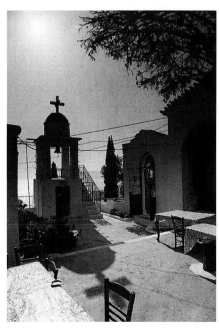

matched to each individual type of glass, these "secondary" images can be reduced greatly. It is not possible, however, to eliminate them altogether.

Fortunately, secondary images are visible in the viewfinder. You can sometimes avoid them just by repositioning the camera or by attaching a lens shade. In fact, it's a good idea to keep a shade in place at all times.

A more insidious problem is side light, which enters the front lens element uncontrolled and travels on through the lens to the film. Unlike a sharp secondary image, this diffuse "flare" is noticeable as a dull, gray haze that seems to envelop the picture and reduce its contrast. The effect is increased by reflections occurring at air-to-glass and glass-to-glass surfaces within the lens. A well-designed lens shade reduces side light, thereby diminishing flare; again, it cannot be totally eliminated. A dirty or scratched front lens element may exacerbate the problem.

Although a shade cannot completely prevent secondary images or stray light, it does provide effective protection, if properly matched to the focal length and picture angle of the lens. A shade that is too long will cause vignetting, particularly with the lens focused at infinity. Conversely, a shade that's too short will not be effective. The best shade is usually the one designed for a particular focal length by the lens manufacturer. Generic, "universal" shades may not furnish the necessary protection, or they may cause vignetting.

A lens shade should be attached at all times, even under seemingly benign conditions such as the diffuse light of an overcast sky.

Fitting a shade to a zoom lens is always difficult. To avoid vignetting, you need a shade that is matched to the zoom's shortest focal length. This works fine at the wide setting, yet is not very effective as a shade against stray light for longer focal lengths. Flare protection is somewhat better with a zoom whose front element retracts into the barrel at telephoto settings.

Pull-out lens shades integrated into the lens design are most convenient, but not universally available. More common are separate bayonet-mount shades, which attach quickly and easily, providing ideal protection for each fixed focal length. Some bayonet-type shades can be mounted in reverse for storage.

Rigid metal or plastic shades are particularly good at protecting the front lens element against mechanical damage. Rubber shades tend to be more flexible, while still providing some shock-resistance. But most rubber shades are equipped with a threaded mount, which is slow to attach, and may cause binding or vignetting problems with filters.

Only an adjustable, bellows-type lens shade can offer ideal protection against flare and sidelight. This design is standard in large-format photography, and generally available for medium- and 35mm-format lenses as well. You adjust the extension of the bellows to precisely match the focal length of the

The art of photography involves careful composition and the correct choice of lens. The contrast in this wide-angle shot was modified by using a graduated neutral-density filter. The fill flash on the stone wall in the foreground helps to balance the overall tonal range of the picture.

lens, with the help of an inscribed scale. The shade is attached to the lens with an adapter, and is equipped with slots for filters, or masks.

In the ultra wide-angle range, employing a lens shade can be a real headache. For example, a shade wide enough to effectively shade a 15mm lens would be the size of an umbrella! As a result, most wide-angle lenses have small, integrated shades with cut-out sides which are more effective against impact damage than against flare. No type of shade is appropriate for fisheye lenses, especially those that produce circular images.

Final Tips

By now you know the most important facts about interchangeable lenses and how to use them. That, however, is not the whole story. Lenses must be kept clean; the image–quality "chain" reaching from the lens to the finished picture has to be maintained; and certain caveats should be remembered when purchasing used lenses. So here are a few final tips to conclude our subject.

Projection lenses are a part of the chain that links the shooting process to the finished picture. They should be of as high quality as the lenses that were used to take the photographs.

Lens Cleaning

Although lens cleaning is quite simple, it should be done carefully because a botched job may ruin the front or rear element. Start with a clean blower-type dusting brush to remove tiny particles of dirt and dust. (Make sure not to touch the bristles, or you may contaminate them with oil from your fingers.) Often, a quick brushing will do. But with fingerprints or other persistent smudges, additional cleaning may be necessary.

Begin by using the blower brush to remove loose dirt so the lens won't be scratched when you wipe it. The latter can be done with a soft chamois, linen, or cotton cloth or with lint-free lens-cleaning tissue. Exhale on the dust-free glass surface, then use the cloth or tissue to clean it. Wipe in a circular motion from the center moving outward. This simple method removes grease spots and even salt-water splashes completely and easily. All smudges should be lifted as soon as possible, because in time they may etch the lens coating. But

don't worry about every tiny, harmless particle of dirt.

Special lens-cleaning fluids should only be employed if wiping has failed. Apply a very small amount of fluid to the cloth or tissue, never directly onto the lens-element surface. It could seep into the lens barrel. Note that tissues and fluids intended for cleaning eyeglasses are not appropriate for photographic lenses.

High-grade lenses can function well for many years, even with hard use. But when such a lens is damaged, it belongs in the hands of the manufacturer or an authorized service facility.

The Chain of Quality

As the old saying goes, a chain is only as strong as its weakest link. This is particularly true of the "quality chain" stretching from the original image to the final print or slide. The goal is to preserve the high performance of your camera lens in all subsequent stages. It is therefore essential to employ products

for projection or enlarging that match the original quality standard.

A good slide projector should display optimum brightness and even illumination all the way to the corners of the image. While a 150-watt projection bulb may suffice in small rooms, a 250-watt model is more versatile, delivering an image of superior brilliance even at short distances. A remote-control device may not affect quality, but it certainly adds to projection convenience. And if you ever want to acquire a dissolve unit, a projector equipped with a dimmer is a wise initial investment.

Top image quality is most easily achieved with slow or medium-speed film. If possible, you may want to produce your own prints. Of course, a high-quality enlarging lens should be your first consideration for sharp prints at all magnifications. Using a sturdy enlarger with bright, even illumination is also important. Modular enlargers are especially practical, because the same chassis can easily be equipped for color printing or for black-and-white printing with either a variable-contrast or condenser head.

If you don't process your own film or make your own prints, choose your photo lab carefully. Professional labs tend to be excellent; they must meet the exacting demands of professional photographers. But this can make them expensive. Some budget labs, while economical, may not meet your quality expectations. Be very critical of the results you get from your lab. If you are unhappy, you have every right to question what went wrong and ask for reprints when appropriate.

One factor affecting lab choice is the type of film you shoot. Though not uncommon, slide film

processing is not as readily available as print film processing. Slide film is more difficult to develop and less forgiving of errors. It requires strict process control. It may be necessary to go to a high-end or professional lab that offers a wider variety of photographic services.

Purchasing Lenses

When purchasing a new lens, you first decide on the type, the focal length, and the speed (maximum aperture). Reading this book can help prevent a number of buying mistakes by illustrating the applications, advantages, and drawbacks of each lens category. Use these guidelines for choosing lenses appropriate to your shooting style. Leading photo magazines regularly publish tests of new lenses, enabling you to judge their performance before making a purchase.

A possible complication with AF lenses, which tests seldom address, is focusing speed. In direct comparisons, we have discovered that some popular cameras focus more quickly with same-brand AF lenses than with independent-brand optics. This is not a universal truth, yet it is worth considering, and probably worth a few tests of your own.

With a new lens, all functions are likely to operate properly. If not, the flaws tend to show up rather quickly, so they can be fixed under warranty. But purchasing a used lens is a totally different matter, because few dealers are willing to guarantee a lens they have acquired as a trade-in. The situation is even more dicey when buying lenses at a flea market, a photographic fair, or through an ad. It may be possible to protect yourself by including a right of return in a

An optical cleaning chamois is especially soft and smooth on both sides, allowing lenses to be cleaned gently and free of lint.

A lipstick-type lens brush should be a part of even the smallest gadget bag.

A lens brush with a blower is also an essential tool. This one features a telescopic neck, allowing the brush to be retracted completely into the blower.

Caution should be exercised when deciding whether or not to use a lens that is scratched or dented on its outer surfaces. The bayonet and the rear lens element must be in near-mint condition to make good photos.

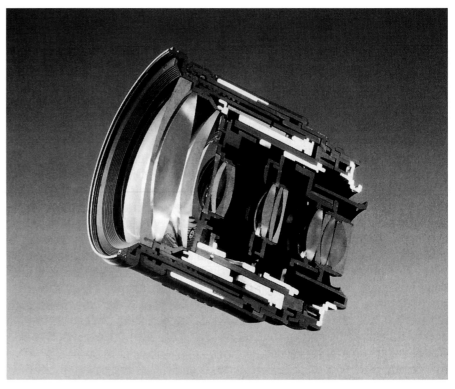

The inner workings of a Tamron AF 28-200mm f/3.8-5.6 lens

The electrical contacts must be in excellent condition to facilitate flawless communication between the camera and the lens.

sales contract, if the vendor agrees. The only practical alternative is to test the lens on the spot.

While it is more difficult to identify a defect in a lens than in a camera, careful observation will reveal a lot. First, the lens' general appearance should be checked. Look out for a scratched or dented barrel, bayonet mount, or filter thread or for a worn-out rubber cover on the focusing ring. All are symptoms of a lens that has seen hard use, perhaps without proper maintenance.

Dents may have been caused by a blow or a fall, which can throw the elements off-center and reduce image sharpness. If the lens was hit hard enough to produce a dent, it may also have caused misalignment of the lens and film plane. If the bayonet mount is not perfectly parallel with the film plane, significant focusing errors will result. A dented thread mount will not allow filters or a threaded shade to be attached.

The condition of the front and rear lens elements is also vital. Slight scratches, just barely visible in strong light, will probably not impair image quality. But deep scratches, especially on the rear element, greatly reduce a lens' performance. Be sure to look through the lens at a bright light source, to make sure there is no grime or cloudiness. On newer lenses, check the electrical contacts as well. They should be clean and not corroded so data will flow uninterrupted between camera and lens.

Thoroughly test all mechanical functions: The focusing helicoid must move smoothly, evenly, and without any play. The diaphragm should close immediately when the lever is tripped, and each *f*-stop opening must be consistent in size.

The aperture ring should turn smoothly and stop positively at each f-stop setting. And the diaphragm blades must not be bent, which you can check most accurately at the smallest opening. Finally, no traces of grease or oil should be visible on the diaphragm blades or elsewhere inside the lens.

We also recommend that you test the lens on your own camera by trying out the most important functions. In aperture-priority AE and manual exposure modes, be sure the shutter speeds change proportionately as you alter the f-stop. Focusing accuracy, whether manual or autofocus, can be confirmed visually in the viewfinder. Also verify that the bayonet locks securely and does not wobble during focusing.

The price of used lenses is determined not just by supply and demand, but also by their condition. Ideally, lenses should look as good as new, with no obvious signs of use. Working photographers (rather than collectors) may accept small abrasions or some missing paint. But if the lens surfaces are clearly scratched or the filter thread is dented, pass the lens by. After all, even the greatest discount cannot make up for blurry pictures.

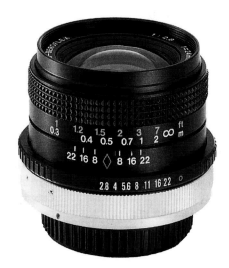

Chrome rings still fascinate nostalgic photographers. If you are buying a used lens for photography, not merely for display, it should be tested rigorously before purchase.

Anyone in search of a Nikkor-S 55mm f/1.2 for their Nikon F camera will have to look hard on the used market. Once found, the lens should be subjected to thorough testing.

Index

More Books in the KODAK Workshop Series

Advanced Black-and-White Photography (KW-19)
Features techniques for achieving high quality at both the camera and darkroom stages of making a photograph, with emphasis on image control, appearance, and fine-art presentation. Includes toning comparisons as well as a section on hand-coloring prints. Over 140 illustrations. Softbound. 8-1/2 x 11″. 104 pp.
ISBN 0-87985-760-9
Cat. No. E 144 1849

The Art of Seeing
A Creative Approach to Photography (KW-20)
Shows you how to take better photographs by studying the elements of the subject, using lighting, composition, color, shape, form, texture, and viewpoint. Explains how cameras, lenses, and films see differently from you. Helps you become visually aware and break through creative barriers. Over 170 illustrations. Softbound. 8-1/2 x 11″. 96 pp.
ISBN 0-87985-747-1
Cat. No. E 144 2250

Black-and-White Darkroom Techniques (KW-15)
Describes the steps for developing, printing, and finishing black-and-white photos. Includes choosing photographic papers, dodging and burning, mounting prints, and more. Over 190 illustrations. Softbound. 8-1/2 x 11″. 96 pp.
ISBN 0-87985-274-7
Cat. No. E 144 0809

Building a Home Darkroom (KW-14)
These step-by-step instructions on building a prototype darkroom will help you plan and build your own. Covers all you need to know about selecting a location, construction, plumbing, electrical, and more. Over 150 illustrations. Softbound. 8-1/2 x 11″. 96 pp.
ISBN 0-87985-746-3
Cat. No. E 143 9991

Close-Up Photography (KW-22)
Covers equipment, lighting, focusing theory, and exposure calculations for close-up photography. Includes tips on controlling movement, foreground and background, plus sections on "hands-and-knees" photography and using a close-up camera with hobbies and crafts. Over 130 illustrations. Softbound. 8-1/2 x 11″. 96 pp. ISBN 0-87985-750-1
Cat. No. E 144 1161

Electronic Flash (KW-12e)
The major sections in this comprehensive book cover: the lighter side—why use flash?, the nature of light, flash basics, electronic flash control, accessory flash, film and filters, creative control, fun flash adventures, and putting flash to work. There are also a troubleshooting section, a glossary, and appendices that cover maintenance and flash performance. Over 175 illustrations. Softbound. 8-1/2 x 11″. 110 pp.
ISBN 0-87985-772-2
Cat. No. E 143 9855

Existing-Light Photography (KW-17)
Discusses the use of high-speed films; camera handling for steadiness; lenses; the correct film for tungsten lighting, fluorescent lighting, and mercury-vapor lamps; and filters. Includes tables that give exposure recommendations for taking photographs in typical existing-light situations, such as in the home, outdoors at night, and in public places. 200 illustrations. Softbound. 8-1/2 x 11″. 88 pp.
ISBN 0-87985-744-7
Cat. No. E 144 1179

Using Filters (KW-13)
Gives creative and technical advice that explains how filters work and how you can use them to capture extraordinary images in color and black and white. Shows how to create mood, add dazzle, render normal colors under artificial lighting, and more. Over 180 illustrations. Softbound. 8-1/2 x 11″. 96 pp.
ISBN 0-87985-751-X
Cat. No. E 143 9868

Using Your Autofocus 35mm Camera (KW-11)
Especially useful for newcomers to 35mm photography. Looks at how cameras work and what accessories, such as lenses and flash units, offer. Also includes composition, picture elements, landscapes, and portraiture. 200 illustrations. Softbound. 8-1/2 x 11″. 96 pp.
ISBN 0-87985-652-1
Cat. No. E 143 9603

NOTES